PORTLAND
SPEEDWAY

PORTLAND
SPEEDWAY

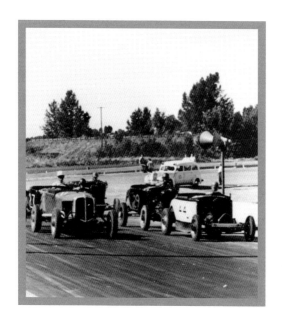

Jeff Zurschmeide

ARCADIA
PUBLISHING

Copyright © 2014 by Jeff Zurschmeide
ISBN 978-1-4671-3146-9

Published by Arcadia Publishing
Charleston, South Carolina

Printed in the United States of America

Library of Congress Control Number: 2013949418

For all general information, please contact Arcadia Publishing:
Telephone 843-853-2070
Fax 843-853-0044
E-mail sales@arcadiapublishing.com
For customer service and orders:
Toll-Free 1-888-313-2665

Visit us on the Internet at www.arcadiapublishing.com

This book is dedicated to the men and women who designed, built, raced, and repaired cars of all kinds at Portland Speedway over the years. They made the shows happen, launched the great careers, and lived the history.

CONTENTS

ACKNOWLEDGMENTS

This book would not be possible without the cooperation of the Portland, Oregon, racing community. Specifically, Mike Bell and the Oregon Motorsports Museum Association (OMMA) have collected and stored a great deal of information on racing at Portland Speedway. Jayson Koch, Sharon Osborne, Ralph Hunt, Jack Corley, Mark Brislawn, Dick Martin, Don Robison, Don Shervey, John Feuz, Del McClure, and many other Speedway Old-Timers provided photographs and information. Jerry Boone covered motorsports at Portland Speedway for the *Oregonian* and provided many photographs of the final years. Bob Kehoe is responsible for the idea of creating this book.

Craig Armstrong, the final manager and promoter for Portland Speedway, provided much-needed detail and context for the final years of the facility. Len Sutton, Rolla Vollstedt, Dick Martin, and others consented to interviews of their memories. The membership of the Racing History group (www.racinghistory.org) provided some vital information on the opening dates of the track.

Finally, my own memories of Portland Speedway would not be possible without my Fizzball Racing teammates: Miq Millman, Scott Fisher, Gordon Jones, George Van De Coevering, Vince Van De Coevering, Dave Rice, and Mary Jane Zurschmeide.

This book includes photographs from many anonymous photographers whose work is now curated by OMMA and the Speedway Old-Timers. I apologize for any errors in identification or appropriate photograph credit. All photographers retain copyright to their work.

INTRODUCTION

A racecourse is more than a loop road, buildings, and grandstands. These facets are necessary, of course, but by themselves they are just like any other stretch of pavement and set of structures. What makes a racetrack is the community of people who come together to put on a show. This book is intended to document and honor the many generations of people who came together to compete, improve their skills, and follow the first rule of Portland Speedway: have fun.

Portland Speedway was built at just the right time in history. In the middle of the Great Depression, auto racing was an affordable sport for both the competitor and the spectator. Portland already had several tracks dating back to the 1910s and a public road-racing history stretching back to hill climbs west of downtown in 1905. World War II forced an end to racing from 1942 to the summer of 1945, but the first postwar races took place just after VJ Day. With a freshly paved track surface, racing really took off in the 1946 season.

The Second World War had a subtle but profound effect on racing at Portland Speedway. Two groups of people entered the racing world in 1946: returning servicemen and those who had been too young to serve in the war. In the immediate postwar photographs in this book, figures such as George "Pop" Koch, Hershel McGriff, and Dick Martin appear as car builders, owners, and drivers before they were of legal age to even get through the gate into the racetrack. These young enthusiasts met with returning servicemen, such as Len Sutton and Rolla Vollstedt, and formed partnerships that would take all of them to the highest levels of American racing.

In the 1950s, Portland Speedway saw its first NASCAR-sanctioned events. In that era, NASCAR was not by any means the household byword for oval-track racing that it is today. For most of Portland Speedway's history to that point, sprint cars and Midget sprints had been the dominant draw, with stock cars, hardtops, and track roadsters in a supporting role. However, the fan appeal of NASCAR soon became apparent, and stock cars took the stage as the leading attraction at the speedway.

As stock cars became more popular into the 1960s, sprint car racers were modifying their machines to run in the increasingly popular Indianapolis 500 and the USAC circuit for Indy-type cars. Portland's car designers and builders, such as Eddie Kuzma, Don Robison, Del McClure, and Rolla Vollstedt, got into the big time by converting big sprint cars to Indy specifications and testing them at Portland Speedway. In 1963, several builders were working simultaneously on rear-engine Indy cars. Vollstedt and Robison debuted their rear-engine machine powered by an Offenhauser engine after extensive work at Portland Speedway.

The 1970s saw the formalization of Portland Speedway as a NASCAR track, with extensive appearances by the series best known as Winston West. It was in this era that many young drivers who would later earn fame in NASCAR's Winston Cup racing series came to Portland. Dale Earnhardt, Bobby and Donny Allison, and many others all visited Portland Speedway on their way to the top. But it was the weekly heartbeat of local racing that paid the bills and kept Portland Speedway as a viable racing facility.

The early 1980s were a challenging period for Portland Speedway, with several rapid changes in management leading to a decline in the quality of racing and the general tenor of the facility. That downturn was reversed by the end of the decade, and both the local weekly racing and the professional series attendance saw a second golden age through the 1990s. Local racing was booming, with yet another generation of new drivers learning their craft in Portland and taking their skills to the national stage. Both Greg Biffle and Mike Bliss came of age in this era. On the professional side, Portland Speedway was among the first courses to see the new NASCAR SuperTruck Series in 1994. The trucks returned every year until 1998, when a shift to live pit stops made Portland Speedway's infield unsuitable for continued use by the series.

This change precipitated a crisis: local racing was still reasonably healthy, but not enough to sustain the track. A new spectator draw was needed, and was offered in the form of a World of Outlaws event. This put manager and promoter Craig Armstrong between a rock and a hard place: Should he try to land another pavement series or make the commitment to return Portland Speedway to its clay-racing roots?

In the end, the decision was forced by influences outside the racing community. Unable to secure financing to improve the decaying pavement because of lease terms, Armstrong had little choice but to shift to a clay surface. He brought in Bill Arnold of Willamette Speedway in Lebanon, Oregon, as a consultant for a smooth and successful transition. The World of Outlaws came to Portland Speedway just twice and then moved on. Without an anchor professional series, there was no way to keep Portland Speedway in operation. The speedway never opened in 2002, and the landowners had the facility razed to the ground in 2003.

This book looks at the history of Portland Speedway, reaching back over the decades to tell the stories of the people who made it their home track. Like Jantzen Beach, Portland Speed Bowl, Rose City Speedway, and others, Portland Speedway is now a ghost track. Yet enthusiasts are working to create a new paved oval racing facility in the Portland metro area, and while it is certainly harder to build such a facility today than it was in the 1930s, a new Portland Speedway has a great chance to succeed as long as there are people who know that watching others race on television is not enough and who want to get out on the racetrack and create their own show.

ORIGINS OF PORTLAND SPEEDWAY 1936–1945

The history of auto racing in Portland goes as far back as 1905, when local magnate E. Henry Wemme organized hill-climb races in Portland's West Hills. Portland was the site of the first-ever US national championship race in 1909—aptly named the Wemme Trophy. The 1909 event was organized by the Portland Rose Festival and sanctioned by the fledgling American Automobile Association. Over the years, AAA gave way to USAC, NASCAR, and other sanctioning bodies. Portland has played a part in America's motorsports history since the beginning. Throughout the first half of the century, racetracks came and went in Portland: Portland Speed Bowl, Rose City Speedway at Rose City Golf Course, Gresham, Jantzen Beach, and of course, Portland Speedway.

The actual founding date of Portland Speedway is uncertain. Many believe that the track dates from the mid-1920s. However, the oldest original sources show the first recorded races at the new Union Avenue Speedway taking place on June 21, 1936. Earlier races scheduled for May 30 and June 14 had been postponed. Articles in the *Oregonian* and *Oregon Journal* newspapers from May and June 1936 describe the track being constructed on a field purchased from a farmer.

At those first races in 1936, Frank Wearne won a two-lap helmet dash and a five-lap heat race. Jimmy Wilburne finished second in those opening races and then beat Wearne in the 25-lap feature race. Art Scovell finished third, Rajo Jack finished fourth, and Ora Bean finished fifth.

Sprint cars (both Big Cars and Midgets) and stock cars were part of Portland Speedway's lineup from the beginning, along with roadsters and hardtops.

In this era, Portland Speedway was a plain dirt course arranged as an oval measuring roughly five-eighths of a mile. There was no shorter track in the infield during this period. Fencing around the facility was put up over the years, along with bleachers for spectators. The track perimeter had no walls at first, though a wooden fence was added early in the track's history.

World War II put a stop to most auto racing in America, with most of the men otherwise occupied and all essential supplies reserved for the war effort. But as the returning soldiers arrived home, they brought two critical things with them: ready cash and a taste for adventure. The combination was magic for Portland Speedway.

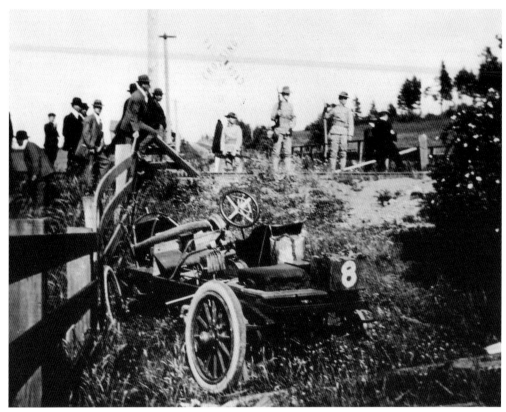

Harry Cohen crashed his car during the 1909 Wemme Trophy race. The 15-mile circuit started on Stark Street, headed west, then turned south on Southeast 96th Avenue in Portland, then east on Division Street, then north on 223rd Avenue in Gresham, and finally back to Stark. (Courtesy of Dale LaFollette.)

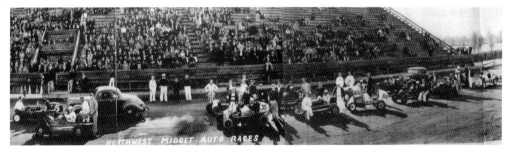

This panoramic photograph of the 1940 Northwest Midget racers is made up of several individual shots. From left to right are Ray Chase in the No. 74 car, Eddie Kuzma standing in white with arms akimbo, Leo Wall in the No. 35 car next to Ron Odney in an obscured car, Gordy Youngstrom in the car next to the No. 100 car, and Bob Gregg in the car parked next to the street car toward the back. (Courtesy of Speedway Old-Timers.)

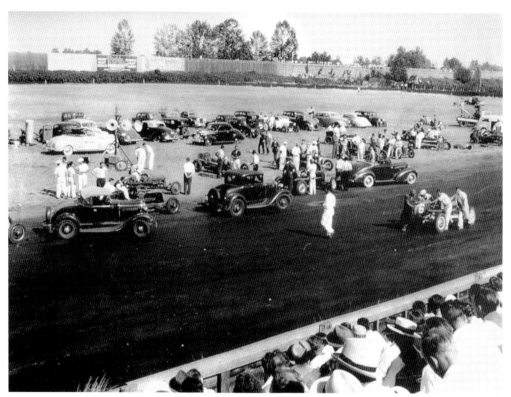

By 1941, the racing surface was compacted and oiled clay, with a tall fence around the track. It is clear where the free seats along Union Avenue (now Martin Luther King Boulevard) provided a view. The infield was a simple grass field. (Courtesy of Speedway Old-Timers.)

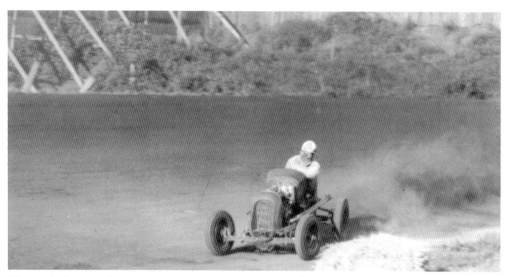

The basic format of a sprint car has not changed over the years, nor has the sideways driving style. The clay surface of the early Portland Speedway was smooth and provided a good racing experience. (Courtesy of Speedway Old-Timers.)

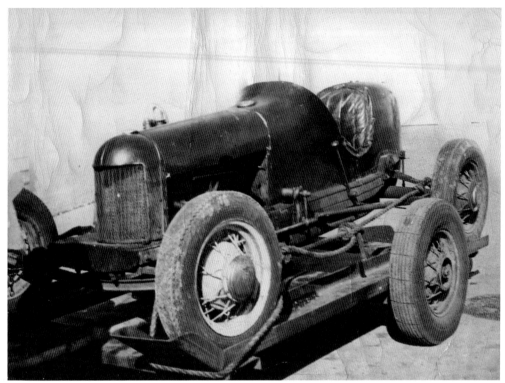

This close look at an early sprint car shows the simple mechanical components scavenged from street cars, transverse leaf springs, wire-spoke wheels, and basic tires. The rope used to tie down the car has been masterfully knotted. (Courtesy of Speedway Old-Timers.)

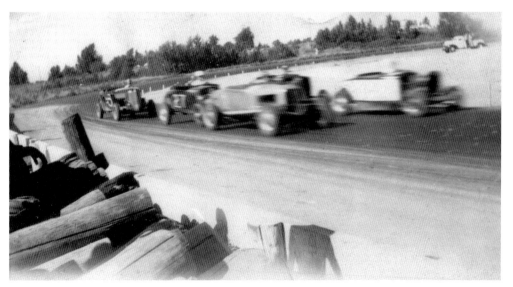

This image of an early roadster race at the speedway shows the simple perimeter fence around the clay racing surface. (Courtesy of OMMA.)

Older roadsters, as seen here in a shot from the early years, were fitted with the lightest bodies and flathead V-8 engines for racing. Roadster racing remained popular after the war, and there are a number of original and modern roadsters still racing today. (Courtesy of OMMA.)

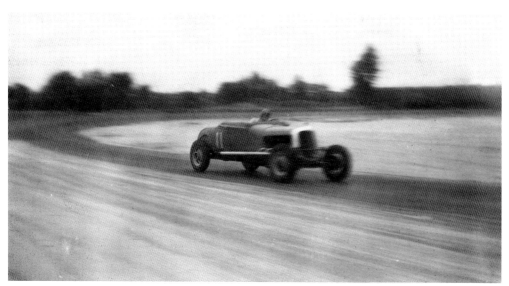

Track roadsters were light, about 2,000 pounds, so the modest horsepower of the flathead V-8 was ample to push the car to great speeds. (Courtesy of OMMA.)

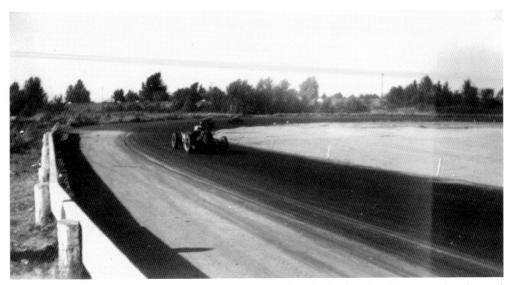

Building and racing track roadsters went hand in hand with the first development of traditional hot rods. The same car might have also been used in drag racing and as basic transportation. (Courtesy of OMMA.)

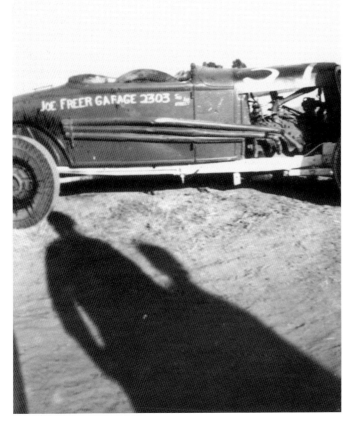

A close look at a track roadster shows the engine has been dropped and moved rearward in the chassis for better weight distribution, and a simple exhaust has been fabricated. It appears Joe Freer has prepared this car. (Courtesy of Speedway Old-Timers.)

Joe Osborne wrecked this sprint car but continued racing afterward. The cars were remarkably tough, and many were rebuilt multiple times. (Courtesy of Speedway Old-Timers.)

Howard and Joe Osborne were brothers who raced. This is an overhead-cam Big Car with Howard Osborne at the wheel. (Courtesy of the Osborne collection.)

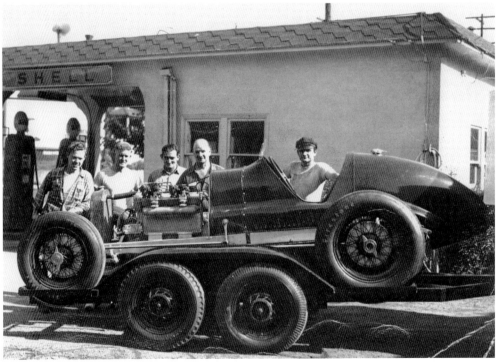

This big sprint car was photographed in front of the Scovell Shell station. Art Scovell was an important early racer of Big Cars from 1936 onward. (Courtesy of Mark Brislawn.)

ORIGINS OF PORTLAND SPEEDWAY: 1936–1945

This is a typical prerace scene at Portland Speedway in the 1930s. Street cars are being used to tow the big sprint cars out and get them started. (Courtesy of OMMA.)

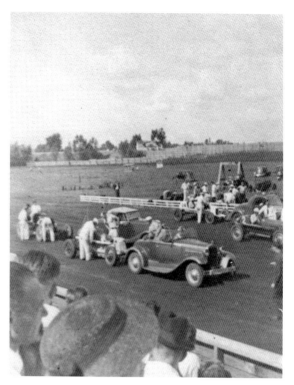

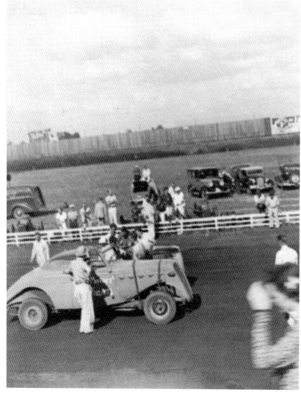

Roadsters prepare to race in the 1930s. All kinds of cars raced in the early years. (Courtesy of OMMA.)

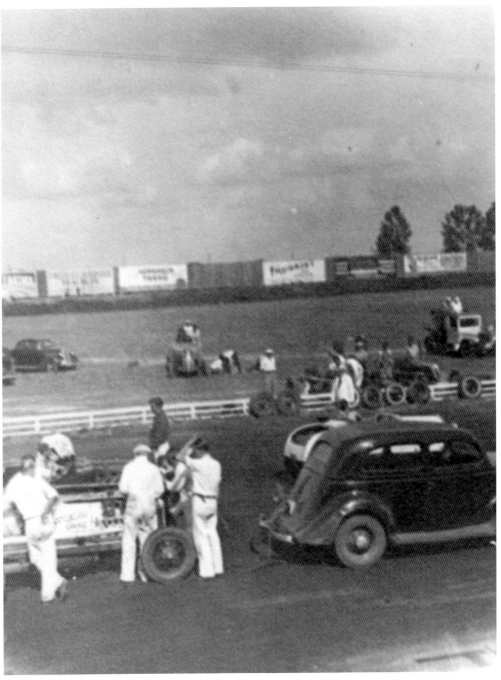

In this photograph, spare tires are seen lined up against the infield fence at the speedway. Changing a tire during a race was a frequent necessity. (Courtesy of OMMA.)

ORIGINS OF PORTLAND SPEEDWAY: 1936–1945

2

POSTWAR BOOM
1946–1960

After a three-year hiatus, the first postwar race at Portland Speedway took place on September 16, 1945. Hershel McGriff entered the race at age 17 and finished ninth in a 1941 Hudson.

"Life moves on, racing moves on to a different phase," Len Sutton once said. For Sutton and many other young men returning from service in World War II, the new phase would launch careers and a passion that would last a lifetime.

The returning servicemen were given a cash stipend following their discharge—$20 a week for 52 weeks. This extra cash allowed them to think about more than just food and shelter, and many of them gravitated to cars and racing.

"When I first started driving after World War II, I was looking for something exciting, daring, and challenging. That was the only thing I had in mind," Sutton said.

Exciting, daring, and challenging is a perfect description of racing at Portland Speedway after the war. Sutton returned home in the winter of 1945 and began racing track roadsters in the summer of 1946.

"I ran a lot of races at Portland Speedway. I cut my teeth in roadsters, then drove Big Cars and Midgets. I drove stock cars and what they called hardtops. Portland Speedway was where most of the action took place. It was my favorite racetrack," Sutton said.

Throughout the rest of the 1940s and 1950s, Portland Speedway boomed under promoters Jimmy Ryan, then Phil and Ron Ail. The track was paved with asphalt and the length of the main course reduced from five-eighths to half a mile in 1946, and an amphitheater drive-in movie theater was created in the infield.

"Ron Ail was an amazing promoter, with this big booming voice. He had a knack for getting newspaper, radio, and television coverage," says Craig Armstrong, manager of Portland Speedway from 1988 until 2002.

The Memorial Day flood of 1948 that destroyed the town of Vanport also flooded Portland Speedway. But the grandstands and track survived the deluge, and the track was soon back in use.

As the 1950s progressed, stock cars were added to the lineup at the speedway, as track roadsters and hardtops ceased running. Sutton moved on to the Indianapolis circuit, and other local heroes followed, including Sutton's longtime friend and car owner Rolla Vollstedt, Indy 500 starter Pat Vidan, Eddie Kuzma, John Feuz, Don Robison, George "Pop" Koch, and Canadian driver Billy Foster.

25c OFFICIAL PROGRAM 25c

PACIFIC COAST CHAMPIONSHIP

350 Lap

STOCK CAR CLASSIC

Sunday, Oct 13, 1946

PORTLAND SPEEDWAY

NORTHWEST SPORTS, INC.

Here is the program from the 1946 season's October race. By this time, Len Sutton had driven in his first event, and Frankie McGowan had clinched the season championship in track roadsters. (Courtesy of the Koch collection.)

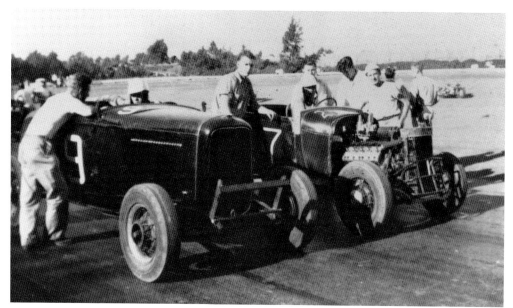

Here are two roadsters getting ready to race in 1946. Frankie McGowan is in the No. 27 car owned by George "Pop" Koch, age 14, shown wearing a white cap. Jimmy Martin is in the No. 9 car. (Courtesy of the Koch collection.)

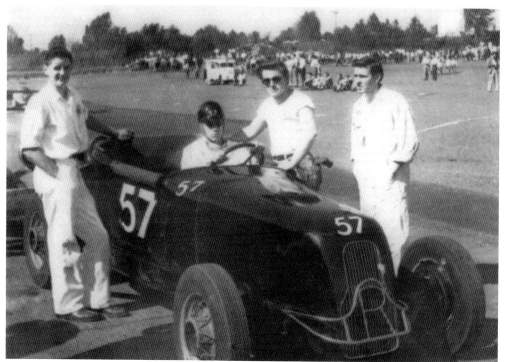

One of the truths of racing is that a driver cannot do everything. A crew, generally composed of friends who volunteer their time, is required to field a race car. The car shown belongs to Al Reamer, with Don Moore in the driver's seat. George "Pop" Koch is at left. (Courtesy of the Koch collection.)

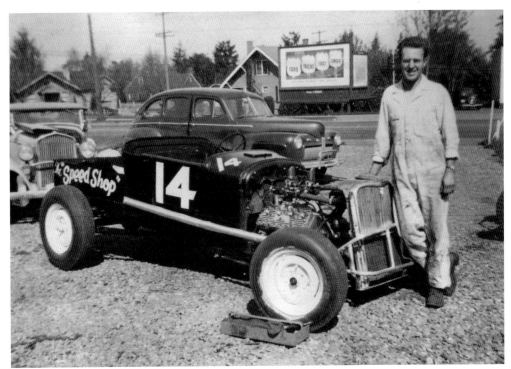

Dick Martin had been too young to go to war, so at age 17, he opened the Speed Shop to build hot rods. He remarked that the purse attracted him to circle-track racing, and he built this pickup-based track roadster. (Courtesy of Dick Martin.)

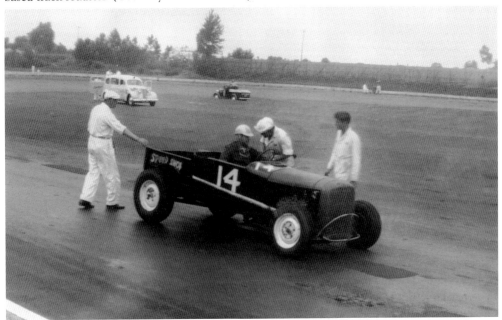

Dick Martin prepares to drive his custom-made track roadster at Portland Speedway around 1946. (Courtesy of Dick Martin.)

Dick Martin straps on his helmet in a track roadster around 1946. (Courtesy of Dick Martin.)

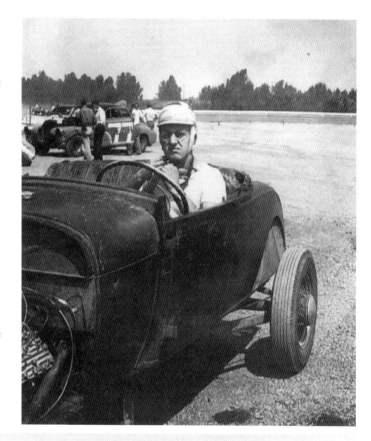

Seen here is 1946 track roadster champion Frankie McGowan at Portland Speedway in George "Pop" Koch's Lincoln V-12 track roadster. (Courtesy of the Koch collection.)

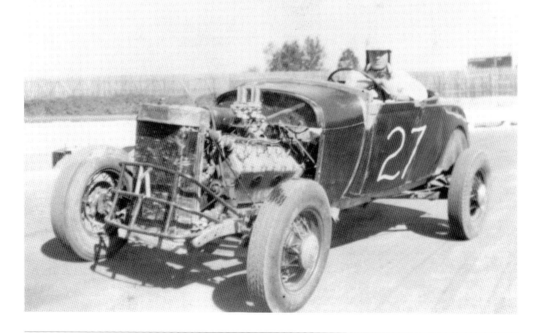

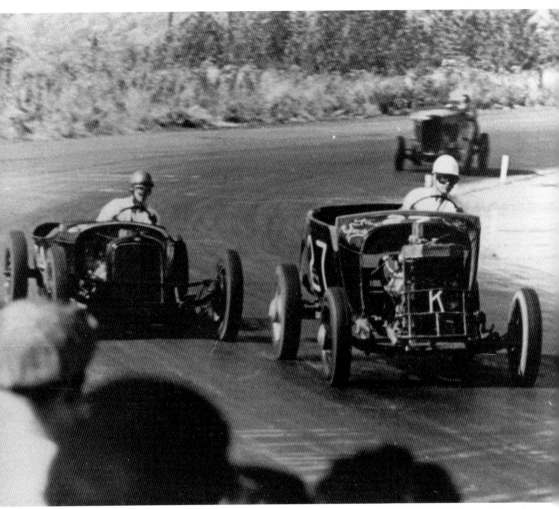

The first track roadster race held at Portland Speedway occurred on August 11, 1946. Frankie McGowan is seen leading in the No. 27 car, and Phil Foubert is in the No. 24 car in second place. (Courtesy of the Koch collection.)

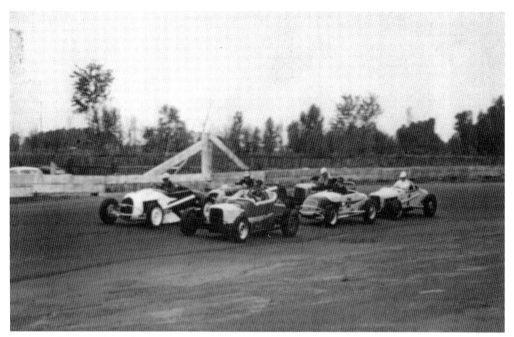

Seen in their track roadsters on April 22, 1951, from left to right, are (first row) Ike Hanks and George Amick; (second row) Bob Donker and Darmand Moore; (third row) Ernie Koch and Lemoine Frey, of California. (Courtesy of the Koch collection.)

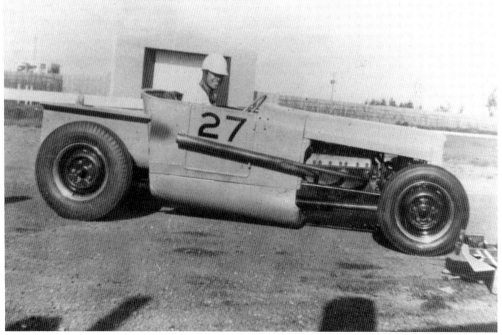

Here is Frankie McGowan in his championship-winning track roadster, powered by a Lincoln V-12 engine. (Courtesy of the Koch collection.)

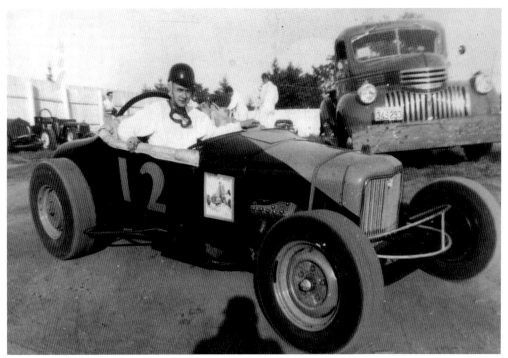

Here is a picture of an unidentified driver in a track roadster. (Courtesy of Don Robison.)

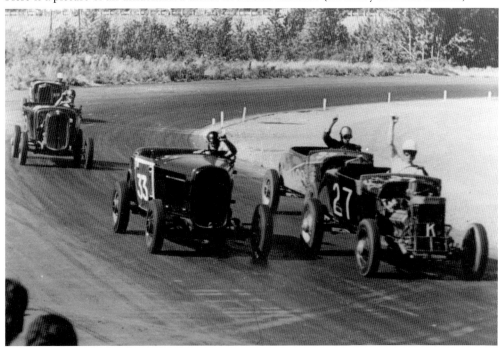

Track roadster drivers raise their hands acknowledging a flag from the starter during a 1946 race. Frankie McGowan is seen in the lead No. 27 car, and Andy Wilson is running second in the No. 33 car. (Courtesy of the Koch collection.)

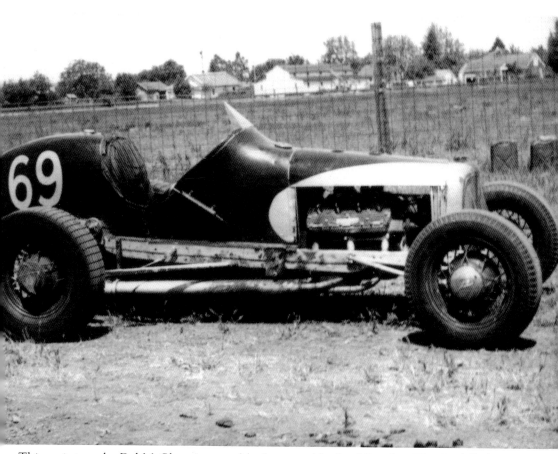

This sprint car by Del McClure is a good look at an old-school Big Car. The Ford flathead engine, Model A wheels, and custom-made bodywork are all representative of the era. (Courtesy of Del McClure.)

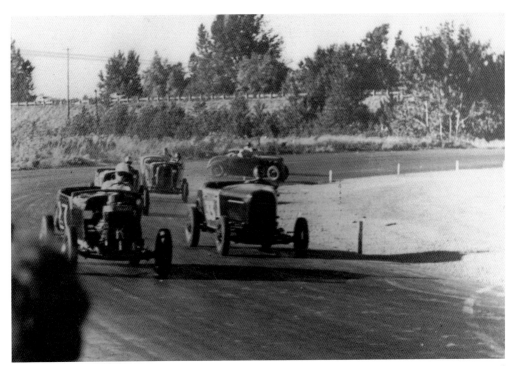

Frankie McGowan is in the lead No. 27 car on the outside, with Andy Wilson running second in the No. 33 car. (Courtesy of the Koch collection.)

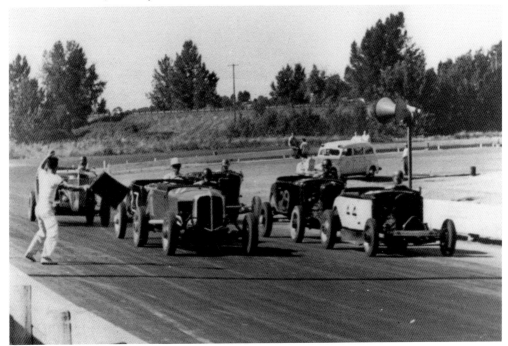

The starter waves the green flag for the track roadsters from right out on the racing surface. This was a common practice in the 1940s. (Courtesy of the Koch collection.)

POSTWAR BOOM: 1946–1960

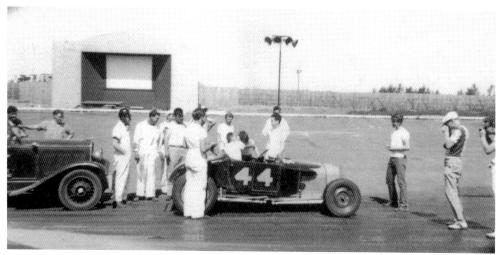

Manny Ayulo accepts a victory kiss from the trophy girl at a roadster race. Ayulo, from California, was killed in practice at Indianapolis in 1955. (Courtesy of the Koch collection.)

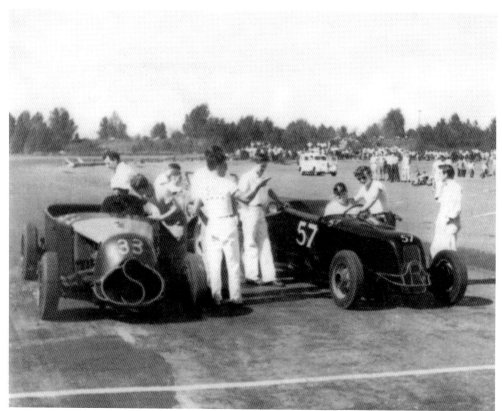

Don Moore is on the inside in the No. 57 car, and Andy Wilson is on the outside in the No. 33 track roadster. (Courtesy of the Koch collection.)

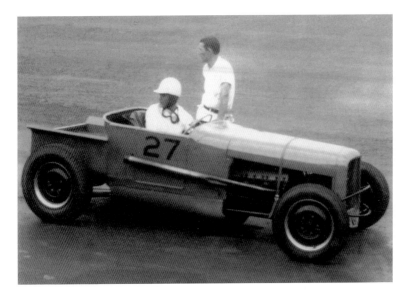

Here, Frankie McGowan is at the wheel of the V-12-powered roadster, with car builder George "Pop" Koch standing by. (Courtesy of the Koch collection.)

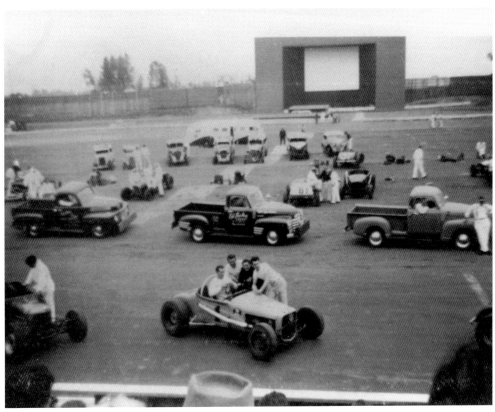

Track roadsters are preparing to race in the late 1940s, with push trucks lined up along the inside edge of the track. (Courtesy of the Koch collection.)

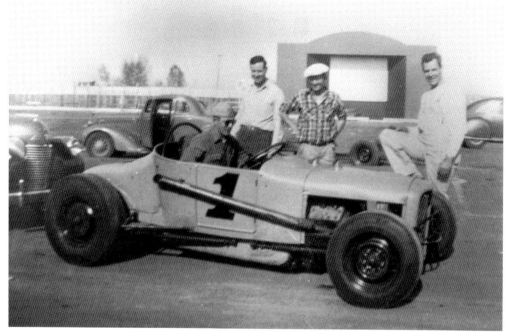

Rolla Vollstedt purchased the championship-winning car—renumbered to No. 1 in recognition of the victory—and shortly replaced the Lincoln V-12 with a flathead V-8. Ernie Koch is seen with his foot on the wheel, and former car owner Dick Compton is wearing the hat. (Courtesy of the Koch collection.)

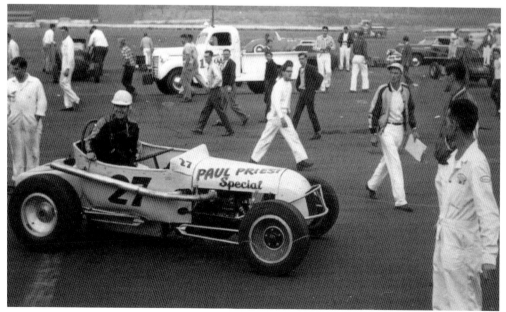

Frankie McGowan and new car owner Rolla Vollstedt parted ways, and Vollstedt hired rookie Len Sutton (seen in the No. 27 car) to drive for him in 1947. The combination was magic. This photograph was taken in 1951. (Courtesy of the Koch collection.)

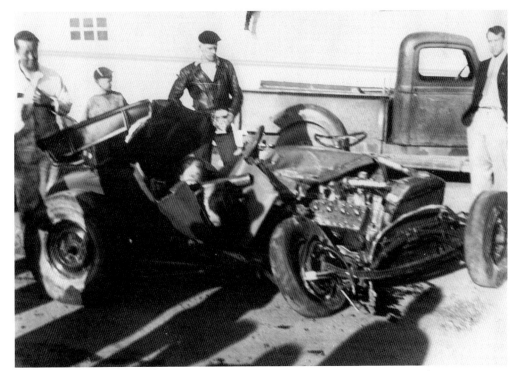

Walt Begaulls wrecked this track roadster in 1947. Sadly, Begaulls did not survive the crash. (Courtesy of the Koch collection.)

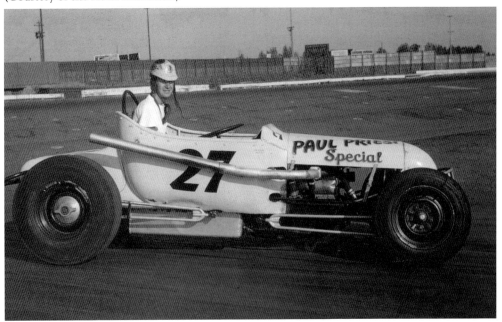

This is Len Sutton posing in the car that George "Pop" Koch built for Frankie McGowan. At this time, the car was owned by Rolla Vollstedt and used a Ford flathead V-8. (Courtesy of the Koch collection.)

Track roadsters line up in 1947. Among the frequent competitors was an African American, Dewey Gatson (not pictured), nicknamed "Rajo Jack" for his habit of using Rajo cylinder heads. Under his racing name, he was listed in the newspapers of the day as the "only negro in organized racing" from the 1930s through the mid-1950s. (Courtesy of the Koch collection.)

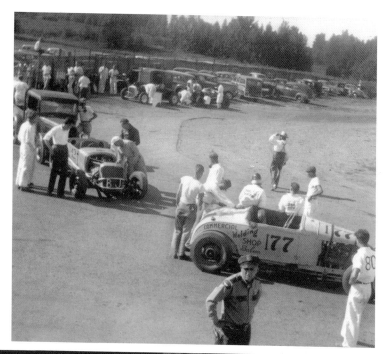

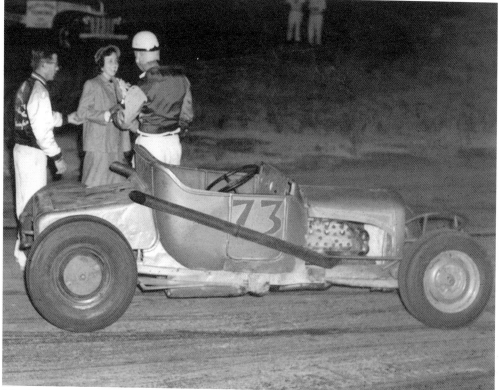

Max Humm drove this No. 73 track roadster, owned by Don Waters, in the late 1940s and early 1950s. (Courtesy of the Koch collection.)

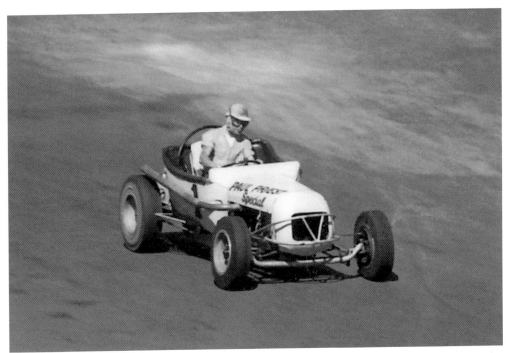

In this image, Len Sutton is driving a track roadster sometime in 1951 or 1952. (Courtesy of the Koch collection.)

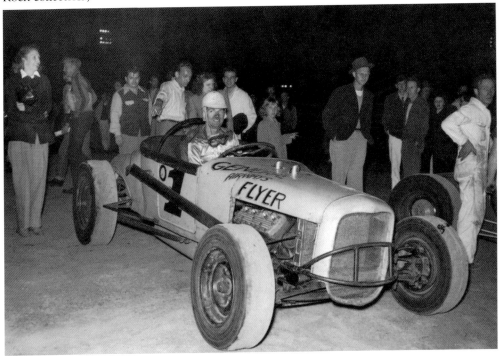

Here is Len Sutton driving with the No. 1 on the car to indicate his status as defending champion. His wife, Anita, stands at left. (Courtesy of the Koch collection.)

POSTWAR BOOM: 1946–1960

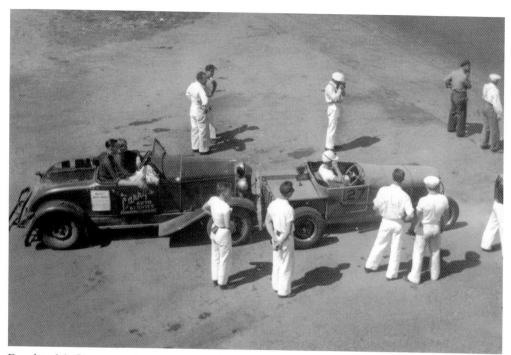

Frankie McGowan waits to time in for a track roadster race in 1947. (Courtesy of the Koch collection.)

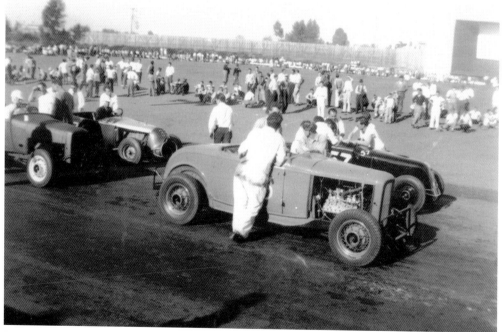

Don Moore is on pole position in the No. 57 track roadster, with an unknown driver in a Don Francis Ford on the outside. Francis went on to become a noted Ford dealer in Portland. (Courtesy of the Koch collection.)

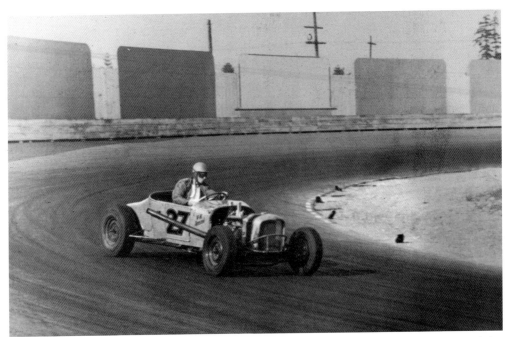

Len Sutton shows off the style that earned him so many championships. (Courtesy of the Koch collection.)

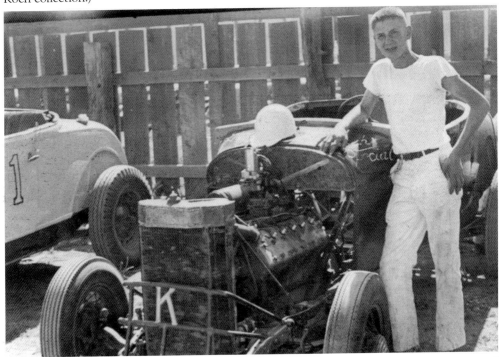

At 14 years old, George "Pop" Koch stands next to the No. 27 track roadster he built and owned in 1946. His car took the championship in that year. Though George was not old enough to be in the pits, he was known as a mechanical genius. (Courtesy of the Koch collection.)

By 1950, track roadsters looked a little more finished and polished than they had at the beginning of the class. These cars were well developed and often rebodied as Big Car sprint cars. (Courtesy of the Koch collection.)

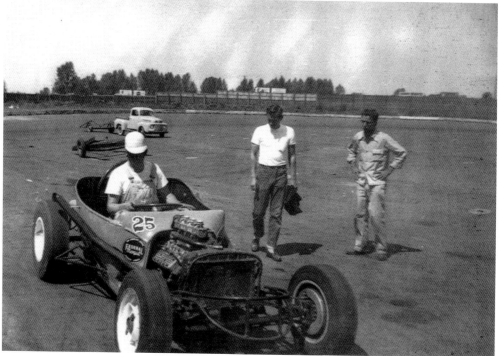

Ernie Koch sits behind the wheel of his track roadster sometime between 1952 and 1953. (Courtesy of the Koch collection.)

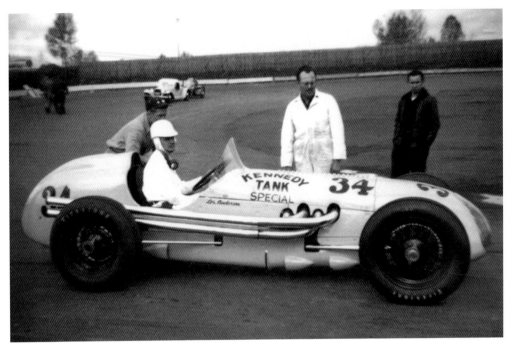

Noted car builder Eddie Kuzma constructed this car for Indianapolis competition and brought it to Portland Speedway for testing in 1948. That is Les Anderson preparing to drive. (Courtesy of the Koch collection.)

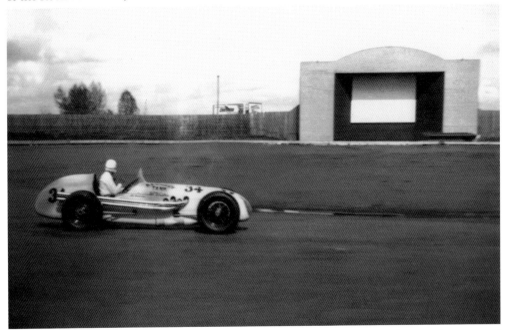

Les Anderson puts the Kuzma Indy Car through its paces at Portland Speedway in the spring of 1948. Several famous Indianapolis cars were tested at Portland Speedway over the years. (Courtesy of the Koch collection.)

POSTWAR BOOM: 1946–1960

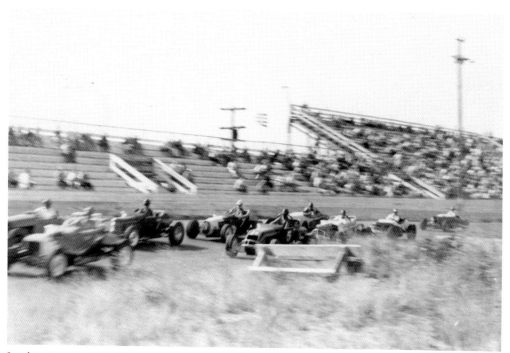

In this image of Big Cars competing around 1950, the familiar configuration of the Portland Speedway grandstands is visible. (Courtesy of the Speedway Old-Timers.)

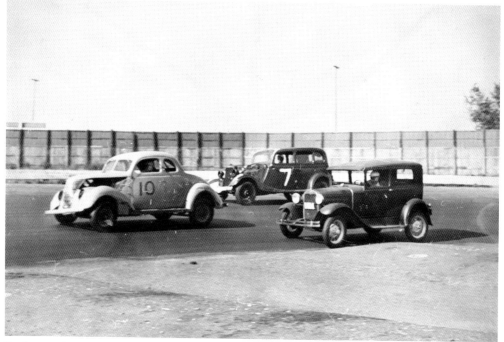

Both popular and cheap, hardtops were known for putting on a great show. (Courtesy of the Speedway Old-Timers.)

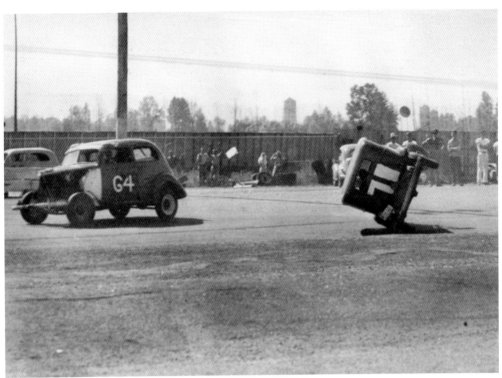

With a high center of gravity and marginal tires, it was not uncommon for hardtops to roll over. (Courtesy of the Speedway Old-Timers.)

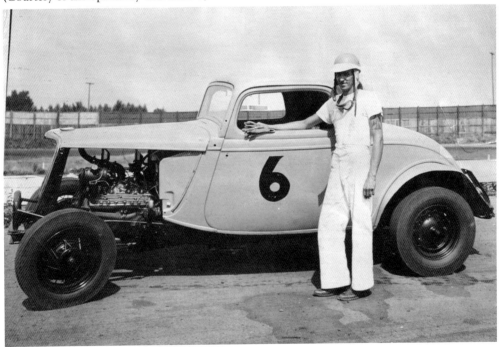

An unidentified hardtop driver poses with his racing machine. (Courtesy of Dick Martin.)

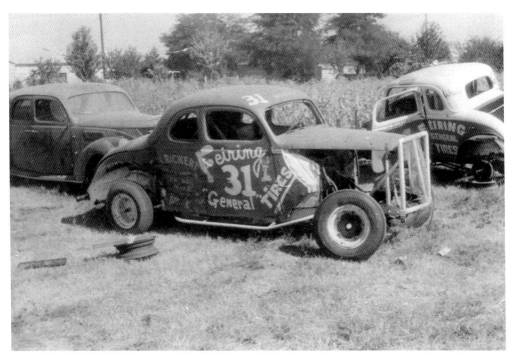

A rather battle-worn hardtop is parked in the boneyard at Portland Speedway. (Courtesy of OMMA.)

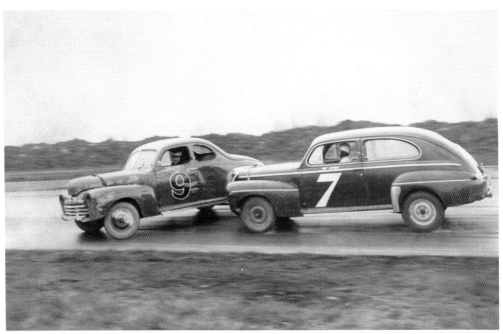

Hardtops often ran in the rain, delivering even more action than usual. (Courtesy of the Speedway Old-Timers.)

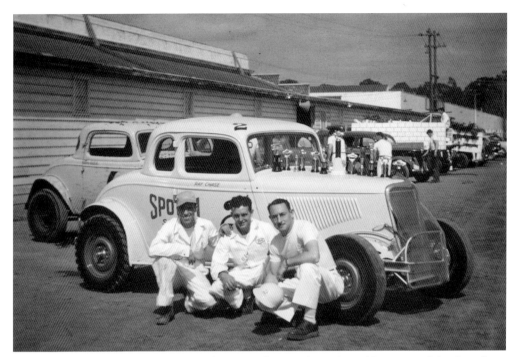

Ray Chase (center) was the driver of the Spotoil Special Hardtop. (Courtesy of the Speedway Old-Timers.)

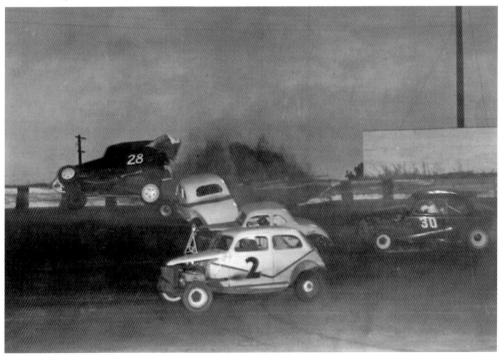

Here is another night at the track, with more hardtop action typical of this era at the speedway. (Courtesy of OMMA.)

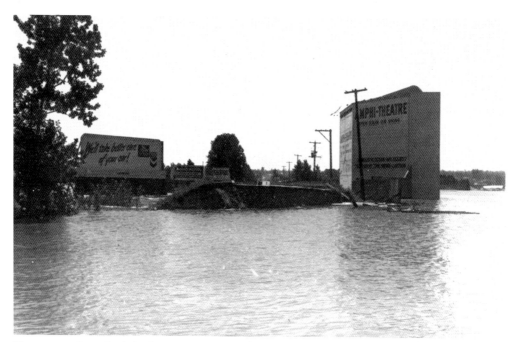

Heavy rains breached the levees restraining the Columbia River on Memorial Day of 1948. The nearby community of Vanport was destroyed and the speedway flooded. Seen here is the drive-in theater screen. (Courtesy of OMMA.)

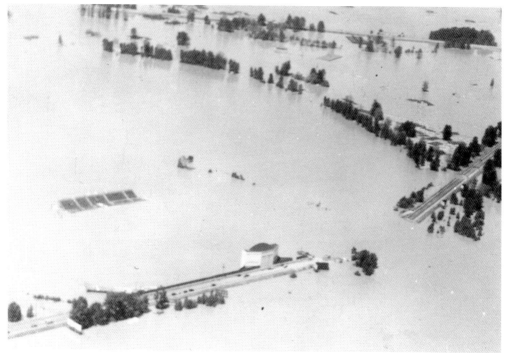

In this aerial shot are the speedway grandstands at left and the drive-in screen at center, along with raised sections of Union Avenue that escaped the flood waters. (Courtesy of OMMA.)

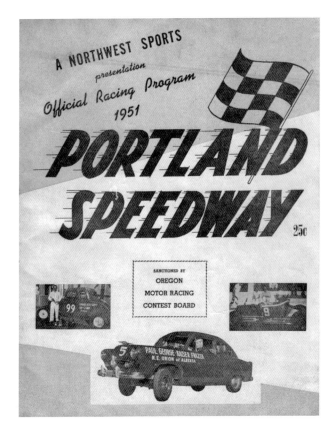

This is a copy of the 1951 racing program for Portland Speedway. Racing was now big business for promoter Jimmy Ryan. (Courtesy of OMMA.)

Len Sutton climbs out of a Big Car sprint machine. That is Del McClure in the coveralls behind the car, at left. (Courtesy of the Speedway Old-Timers.)

Noted driver Bob Gregg is seen sitting in a Ranger Special, with "Wild Bill" Hyde standing by. The Ranger Special was named for its Ranger aircraft engine, purchased as war surplus. (Courtesy of Mark Brislawn.)

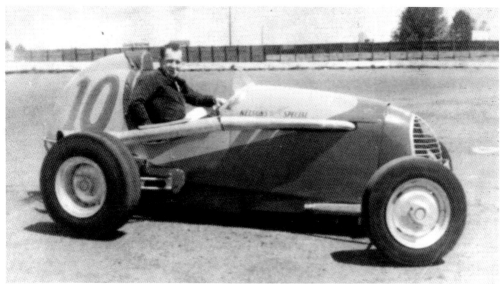

Here is the one, the only, renowned race car driver Clark "Shorty" Templeman sitting in a Ranger Special. (Courtesy of Mark Brislawn.)

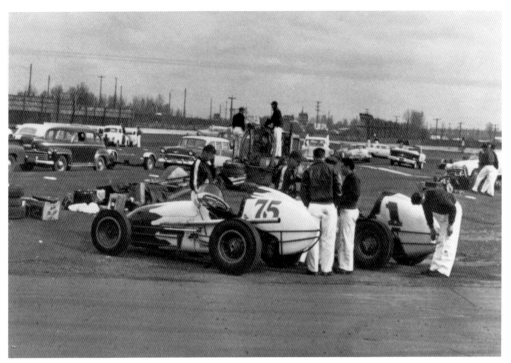

Big Cars are seen getting ready for the Labor Day race in 1956. (Courtesy of the Koch collection.)

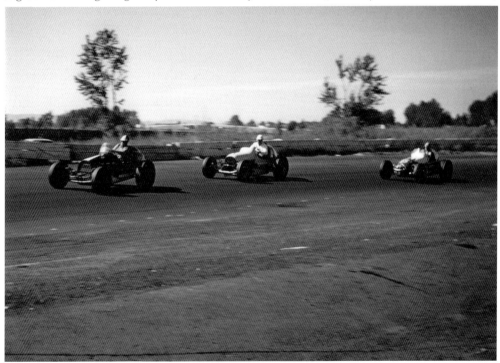

Labor Day was a traditional day for a big racing event at Portland Speedway. Here, Big Cars are competing in 1956. (Courtesy of the Koch collection.)

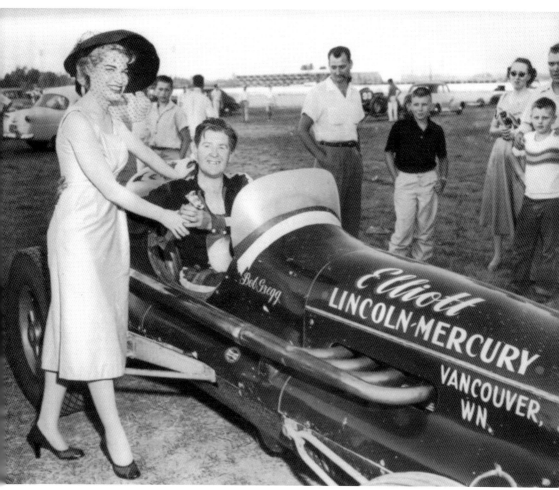

Lila Jackson appears with driver Bob Gregg in the former Blue Crown car that competed at Indianapolis from 1939 to 1947. (Courtesy of Don Robison.)

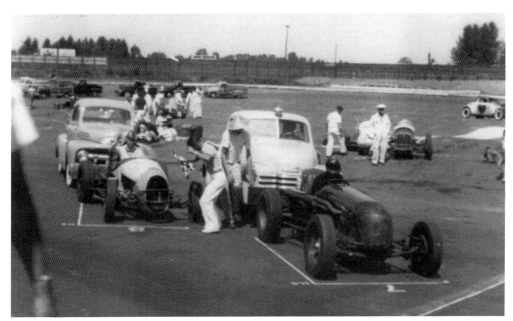

Pat Vidan parks Big Cars in preparation for a race. (Courtesy of the Koch collection.)

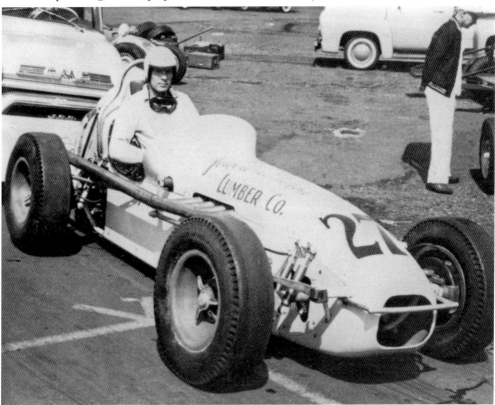

Ernie Koch prepares to race his Big Car in this c. 1960 photograph. (Courtesy of the Koch collection.)

POSTWAR BOOM: 1946–1960

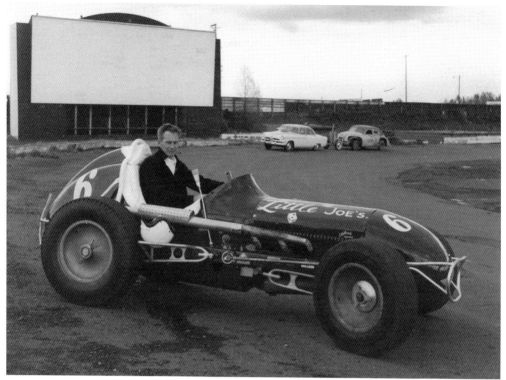

Clark "Shorty" Templeman poses in a Big Car around 1960. Templeman had five Indianapolis 500 starts from 1955 to 1962, finishing fourth in 1961. (Courtesy of the Koch collection.)

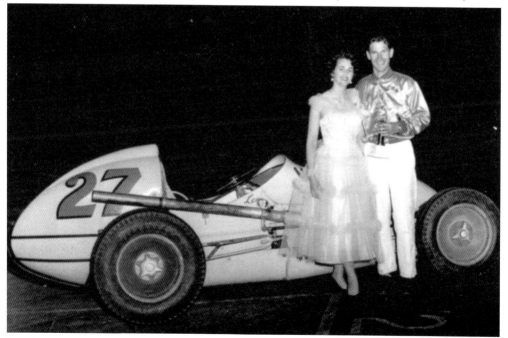

Len Sutton poses with an unidentified trophy girl in 1953. (Courtesy of the Koch collection.)

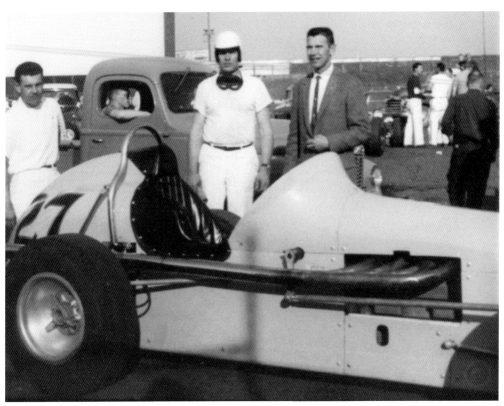

This image shows Len Sutton (right, wearing tie) with Ernie Koch (wearing helmet) and Donald "Duck" Collins (left, behind the car). (Courtesy of the Koch collection.)

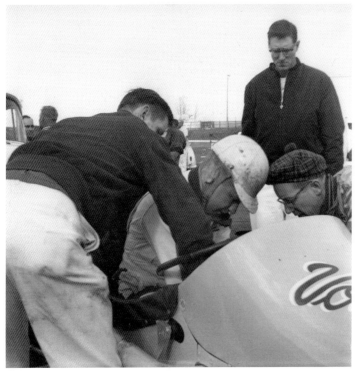

Clark "Shorty" Templeman is belted into a car by Rolla Vollstedt (wearing hat) and George "Pop" Koch in 1955, with John Feuz in the background. (Courtesy of the Koch collection.)

POSTWAR BOOM: 1946–1960

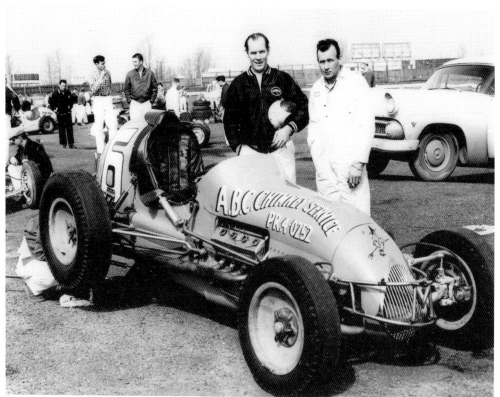

These two gentlemen are Ernie Koch (left) and Keith Randall, pictured in 1961. (Courtesy of the Koch collection.)

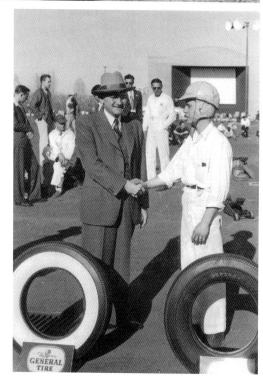

George Amick (right) shakes hands with Oregon governor Earl Snell in 1946 before winning a 350-lap race. (Courtesy of the Koch collection.)

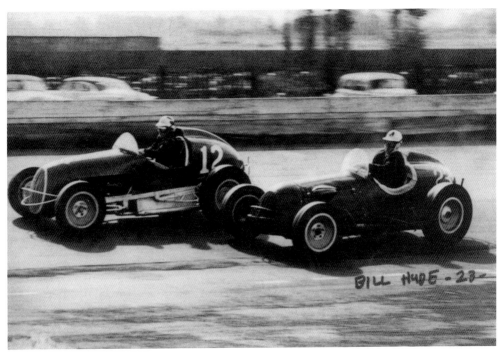

Chuck Tonz (No. 12) leads Bill Hyde at Portland Speedway sometime between 1952 and 1953. (Courtesy of the Koch collection.)

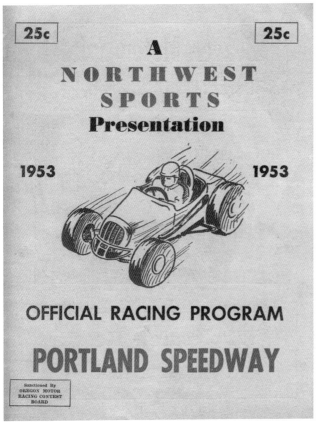

Here is another racing program from Portland Speedway in 1953. By this time, Paul and Ron Ail had taken over from Jimmy Ryan. (Courtesy of the Koch collection.)

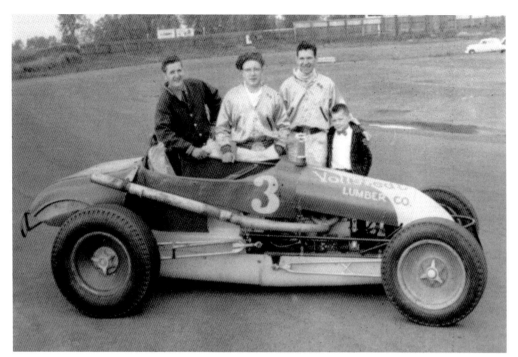

From left to right are George "Pop" Koch, Rolla Vollstedt, and Len Sutton. The boy is unidentified. (Courtesy of the Koch collection.)

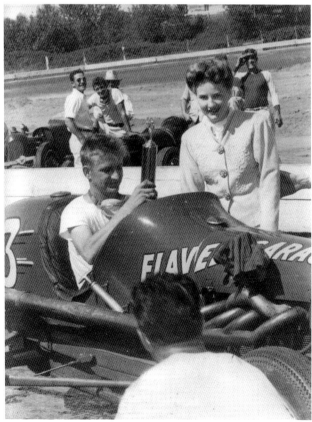

This lucky driver is accepting a trophy from a Gloria Lavan trophy girl in 1946. Howard Osborne is seen at the back with goggles around his neck. (Courtesy of Del McClure.)

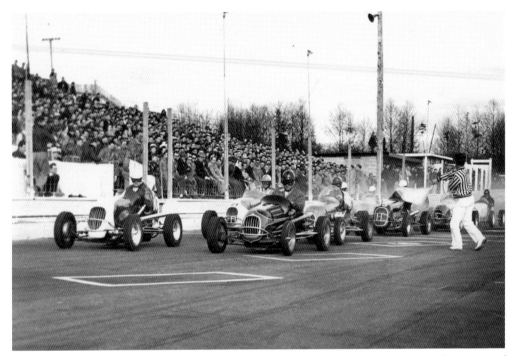

Howard Osborne is pictured on the pole position at the start of this Midget race. (Courtesy of the Osborne collection.)

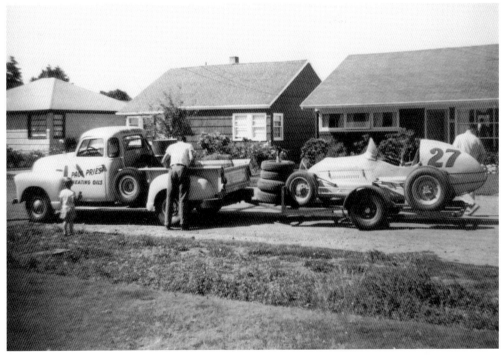

Len Sutton and George "Pop" Koch prepare for a race at Portland Speedway in 1954. Pop's son Jayson, age two, is standing at left. (Courtesy of the Koch collection.)

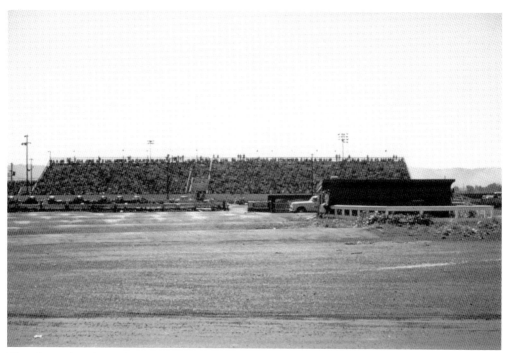

This shot, taken from the top of the concession stand near the back straight, shows the grandstands and crowd for the 1956 Labor Day race. (Courtesy of the Koch collection.)

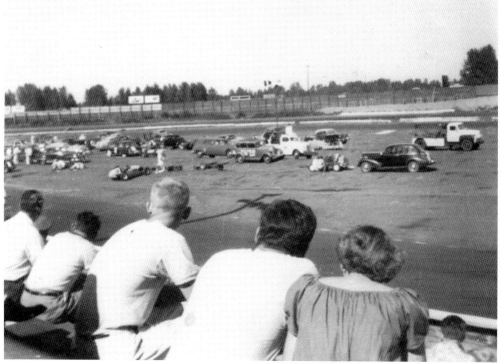

Here is the view from the stands in the early 1950s. (Courtesy of the Speedway Old-Timers.)

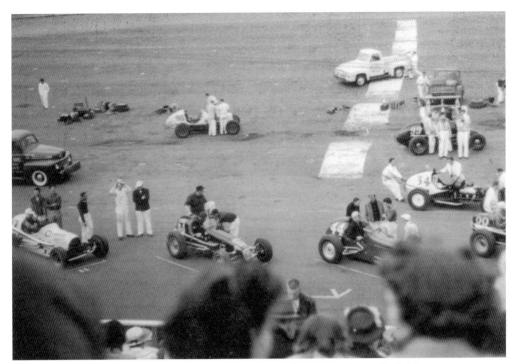

Oh, the trials and tribulations of the prerace process. This image shows the Midget racers getting ready to line up to race on May 9, 1954. (Courtesy of the Koch collection.)

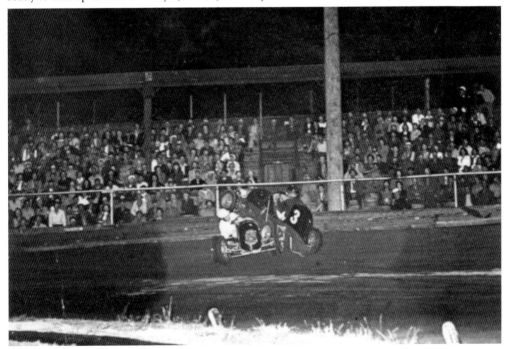

Here are two drivers trying to occupy the same space at the same time in a nighttime Midget race. (Courtesy of OMMA.)

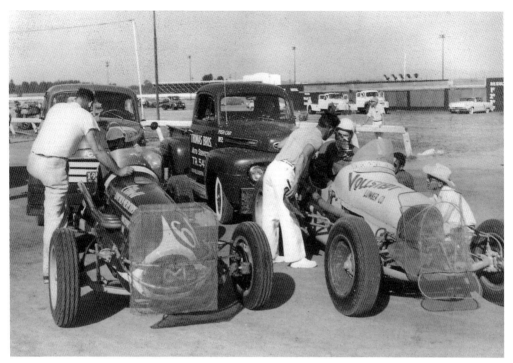

Rolla Vollstedt's Big Car (right) and another car are seen at nearby Portland Meadows. (Courtesy of Don Robison.)

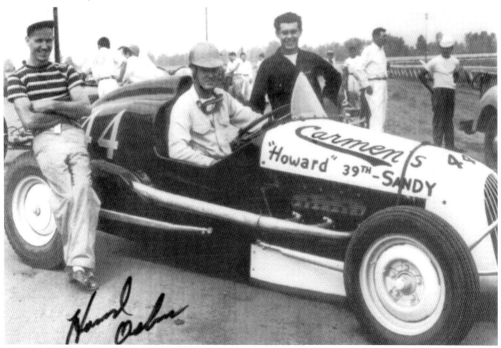

In this image of driver Howard Osborne in 1950, Duck Collins is shown at right, with a Mr. Merritt at left. (Courtesy of the Osborne collection.)

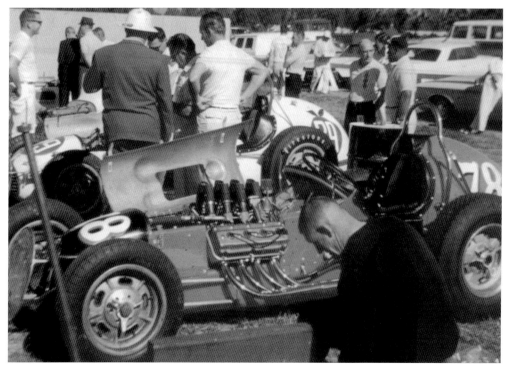

This is another image of Howard Osborne preparing to race. (Courtesy of the Osborne collection.)

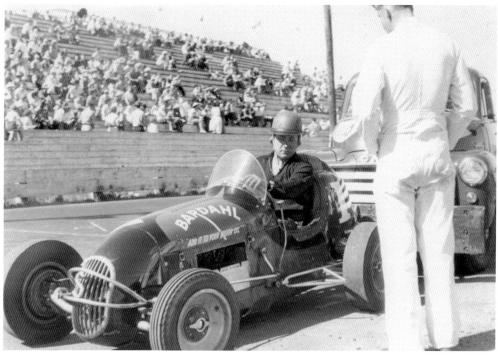

Midget sprint cars were a big draw at Portland Speedway, and Bardahl oil additive was a major sponsor. (Courtesy of the Speedway Old-Timers.)

Joe (standing at left) and Howard Osborne (seated in car) celebrate a victory in a Big Car. (Courtesy of the Osborne collection.)

Bob Gregg is sitting in the car, with Howard Osborne (standing center-left with his hand on the car), Don "Duck" Collins (in white shirt, behind trophy), and many fans helping to celebrate a victory. (Courtesy of the Osborne collection.)

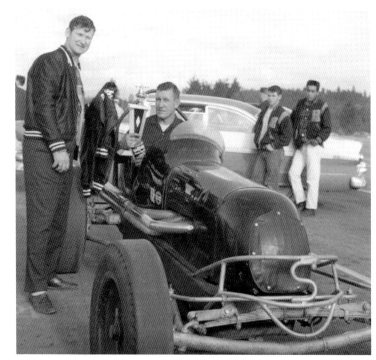

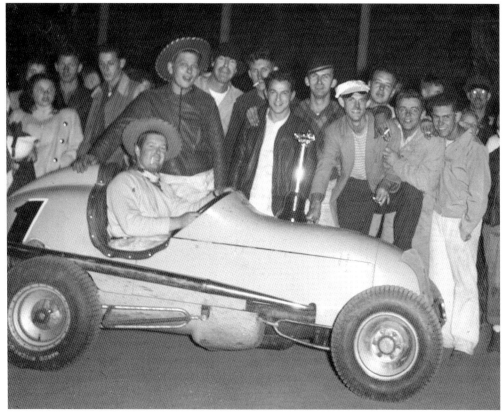

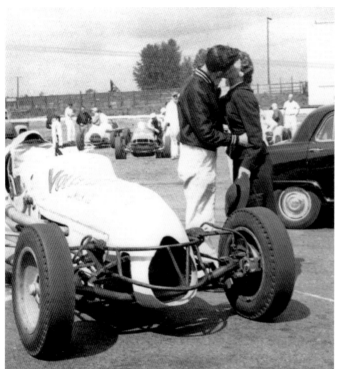

Len Sutton gets the traditional kiss from the trophy girl after a victory. (Courtesy of OMMA.)

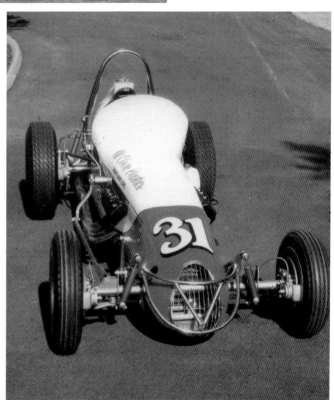

Del McClure built this car for Indianapolis competition in 1957. (Courtesy of Del McClure.)

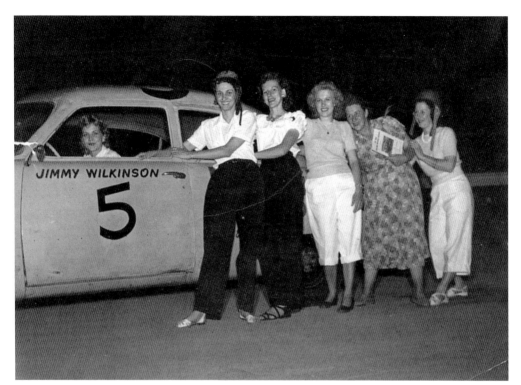

Helen Gregg, Mae Moore, and Mary Osborne are among the women in this picture. (Courtesy of the Osborne collection.)

Howard Osborne poses in his driver's gear, complete with goggles and helmet. (Courtesy of the Osborne collection.)

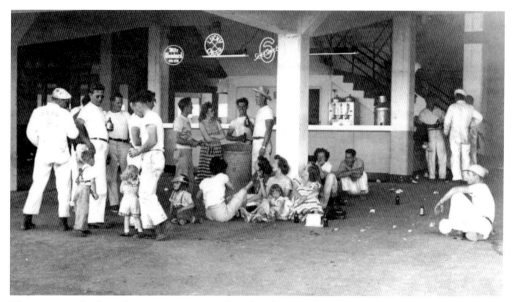

This is a rare look at the concession stand under the grandstands at Portland Speedway in the 1950s. (Courtesy of OMMA.)

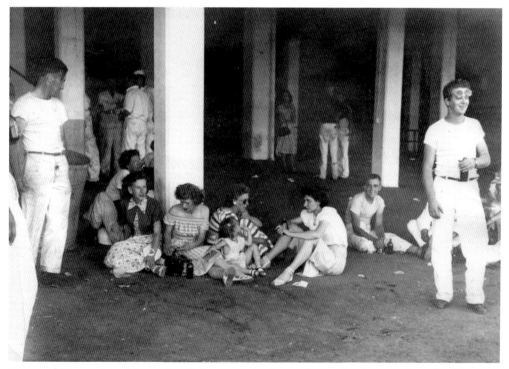

Darmand Moore, Mae Moore, Joe Osborne, and others relax under the grandstands. (Courtesy of the Osborne collection.)

In this 1957 program, Paul and Ron Ail were promoting the races at both Portland Speedway and Jantzen Beach Arena. (Courtesy of OMMA.)

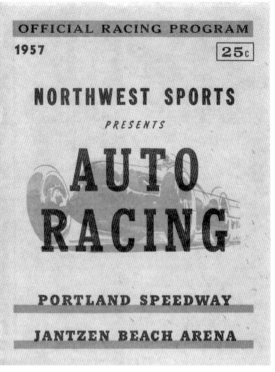

OFFICIAL RACING PROGRAM
1957 25¢

NORTHWEST SPORTS

PRESENTS

AUTO RACING

PORTLAND SPEEDWAY

JANTZEN BEACH ARENA

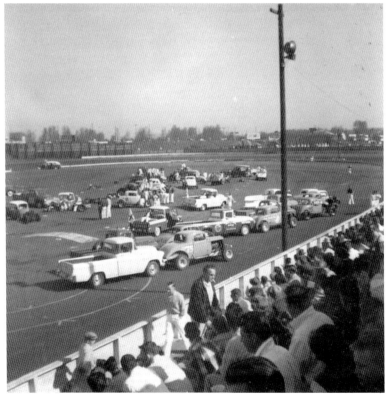

Here are a group of hardtops getting ready to race at Portland Speedway in 1957. (Courtesy of OMMA.)

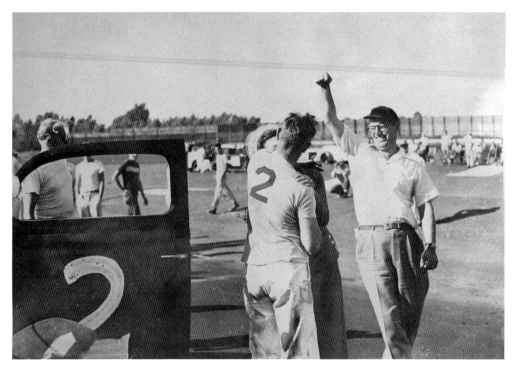

An unidentified hardtop driver celebrates a win by kissing the trophy girl while a friend celebrates the victory. (Courtesy of Dick Martin.)

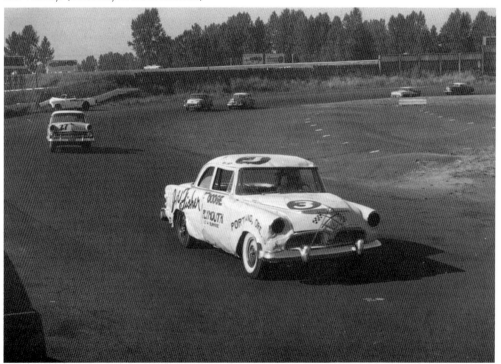

Len Sutton is behind the wheel of this No. 3 stock car. (Courtesy of OMMA.)

POSTWAR BOOM: 1946–1960

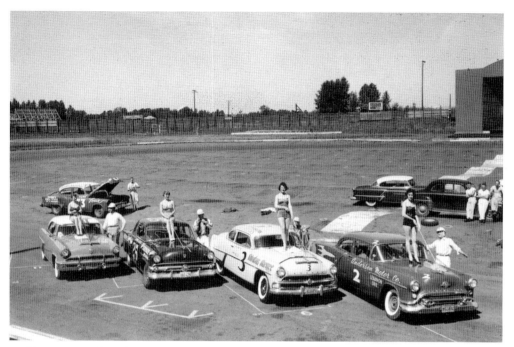

In this image are the Gloria Lavan models posing on several stock cars. (Courtesy of the Speedway Old-Timers.)

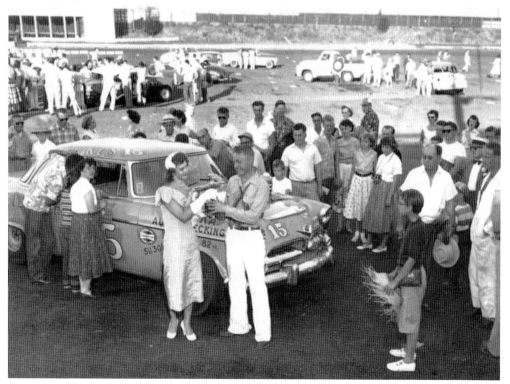

A trophy girl awards a stock car prize while the fans look on. (Courtesy of OMMA.)

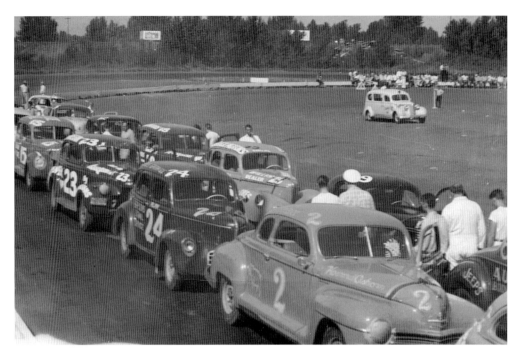

Stock cars are lined up and ready to race. Howard Osborne is seen at front in the No. 2 car. (Courtesy of the Osborne collection.)

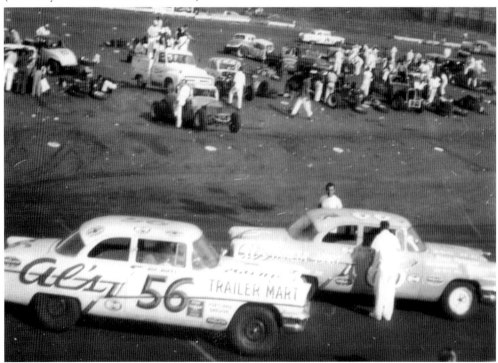

In addition to the stock cars lined up in racing position, several hardtop vehicles are in the background of this photograph from the mid-1950s. (Courtesy of the Speedway Old-Timers.)

The waves in the infield for the drive-in theater are visible in this shot of stock cars lining up to race. (Courtesy of the Speedway Old-Timers.)

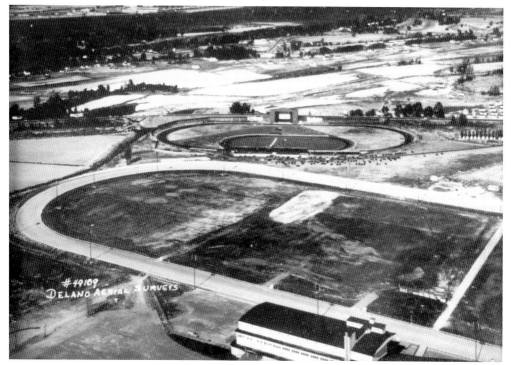

Portland Speedway is shown here as it appeared in the 1950s, with Portland Meadows in the foreground. (Courtesy of OMMA.)

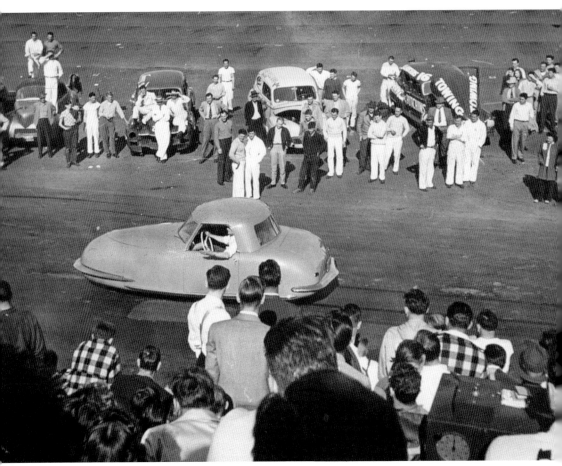

This futuristic prototype was displayed at the speedway in the 1950s. (Courtesy of the Speedway Old-Timers.)

3

RACING ON
1960–1980

Racing at Portland Speedway continued through the 1960s with some amazing developments. The old Big Car sprint cars were used for every level of racing, from local dirt tracks to the Indianapolis 500. Using this ladder, many drivers, such as Len Sutton, Billy Foster, Art Pollard, Bob Gregg, Les Anderson, and others, made the jump to national exposure. Local builders and car owners, such as Eddie Kuzma and Rolla Vollstedt, and the designers and mechanics, such as Don Robison, George "Pop" Koch, John Feuz, and Grant King, all ended up in Indianapolis at one time or another.

Portland Speedway was used as a test track for the newly developed Champ Cars, specifically a new rear-engine Offenhauser-powered car owned by Rolla Vollstedt, designed by Don Robison, and built by a team including Harold Sperb, John Feuz, Keith Randol, George "Pop" Koch, Grant King, Don "Duck" Collins, and others in 1963.

As a venue for local racing, stock cars began to have a greater presence, and many sprint cars ran as supermodified cars by adding a removable hardtop. The old hardtop racers faded away, and a new generation of drivers emerged.

From the early to mid-1950s, Paul Ail and his son Ron Ail managed the track and handled promotions. That era came to an end in 1975, when Ted Pollock took over. Pollock was a past sponsor of Hershel McGriff and the owner of Pollock Motors. In the late 1970s, the team of J.J. Zafino and Barbara Goulet replaced Pollock, and then one of the owners of the underlying land, Bill Nikkila, ran the track for one year about 1980.

One of the stars of the speedway in this era was starter Pat Vidan. Old-timers recall that Vidan had a flair for showmanship, waving his flags dramatically right down on the racing surface. With his sense for the theatrical aspect of racing, he encouraged drivers to dress up their cars and raise the general level of the show at the speedway. Vidan was identified as a special talent and went on to serve as starter at Indianapolis Motor Speedway from 1962 to 1979—yet another veteran of Portland Speedway who made it to the big time. After Vidan's departure, Ed Rose became Portland Speedway's starter for many years.

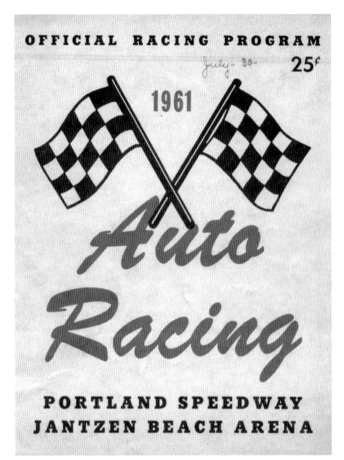

OFFICIAL RACING PROGRAM

July- 30- 25¢

1961

Auto Racing

**PORTLAND SPEEDWAY
JANTZEN BEACH ARENA**

This racing program from 1961 covered both Portland Speedway and the neighboring track in Jantzen Beach. In this era, the Ail family promoted racing at both facilities. (Courtesy of the Speedway Old-Timers.)

Below is an image of stock car racing about 1960. NASCAR arrived at Portland Speedway in 1956 with the Grand National Pacific Coast Series. (Courtesy of the Speedway Old-Timers.)

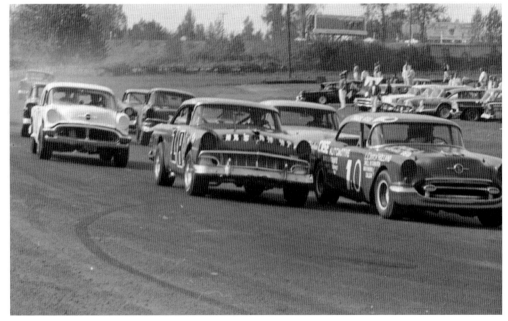

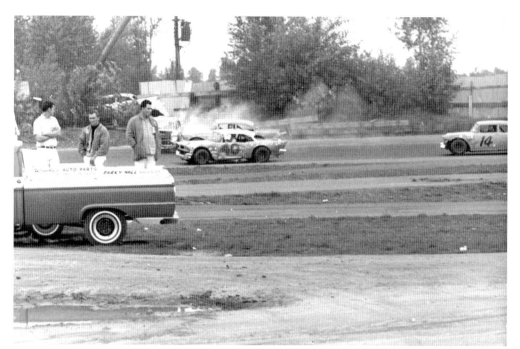

Push truck officials have not had time to react to the crash happening behind them as one car is seen going over the edge and knocking down a telephone pole. (Courtesy of the Speedway Old-Timers.)

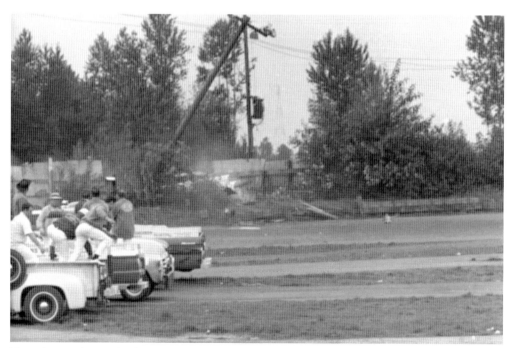

Now alert to the crash, the push truck crews move to respond to the driver who hit the telephone pole. (Courtesy of the Speedway Old-Timers.)

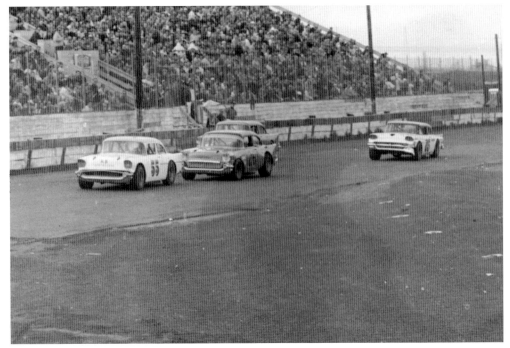

The popularity of stock car racing rose dramatically in the 1960s, with full stands and further improvements, such as the catch fencing along the front straight. (Courtesy of OMMA.)

Portland Speedway's trademark blackberry bramble along turns No. 3 and No. 4 is clearly visible. Getting a car into the blackberries was much easier than getting it back out again. (Courtesy of OMMA.)

This 1962 program reflects the stylistic art of the era. Once again, the program covers both Portland Speedway and Jantzen Beach Arena. (Courtesy of OMMA.)

1962

25¢

auto racing

OFFICIAL RACING PROGRAM

PORTLAND SPEEDWAY
JANTZEN BEACH ARENA

This fine gent is Kuzie Kuzmanich with his 1961 Pontiac stock car, with which he won the 1961 championship. (Courtesy of OMMA.)

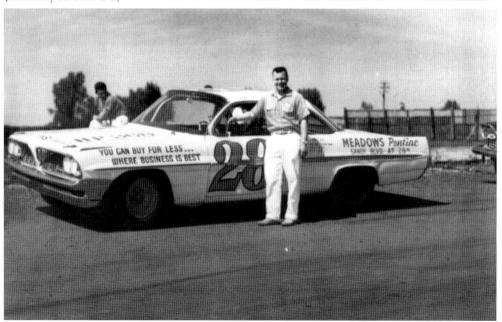

YOU CAN BUY FOR LESS...
WHERE BUSINESS IS BEST

MEADOWS Pontiac
SANDY BLVD AT 28TH

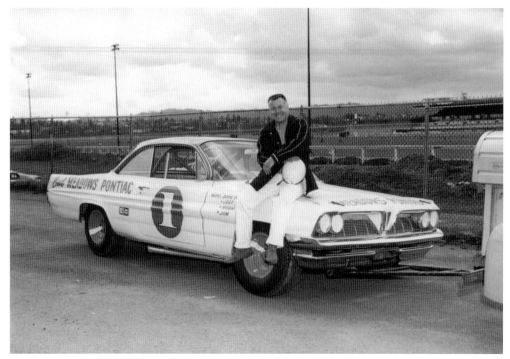

Here is another image of Kuzie Kuzmanich in 1962 with the same car, only now it bears the No. 1 to indicate that the driver is the defending champion. (Courtesy of the Koch collection.)

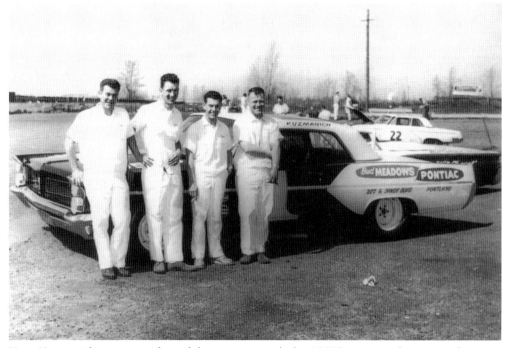

Kuzie Kuzmanich is seen at right with his crew, posing by his 1963 Pontiac stock car, again boasting the No. 1 of the defending series champion. (Courtesy of OMMA.)

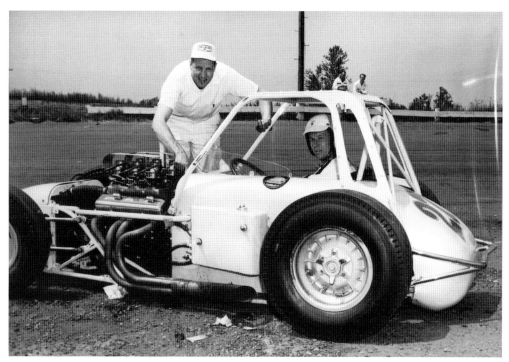

John Feuz (left) is pictured with Billy Foster in a sprint car shown with a removable hardtop, classifying it as a supermodified. (Courtesy of Don Robison.)

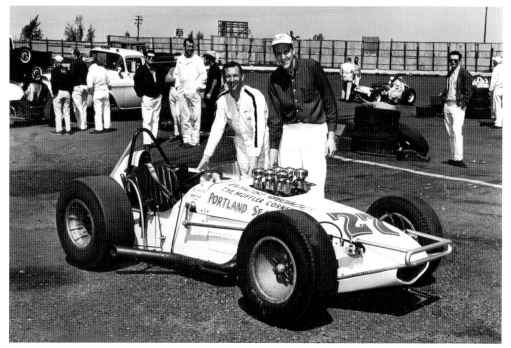

Billy Foster (left) and John Feuz pose with the same car, now racing as a sprint car without the hardtop. (Courtesy of Don Robison.)

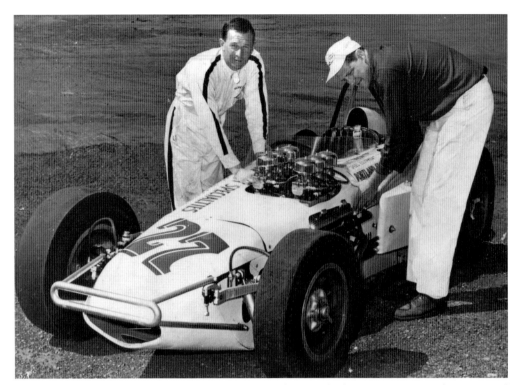

John Feuz and Billy Foster are once again seen working with their sprint car. Both Foster and Feuz made it to Indianapolis with the experience they gained in sprint car racing. Foster was killed in 1967 during practice for a NASCAR race at Riverside International Raceway. (Courtesy of Don Robison.)

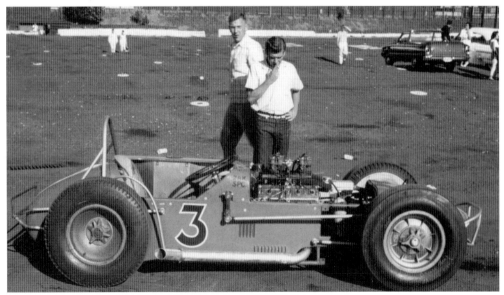

This sprint car, being admired by spectators, was driven by Ernie Koch and owned by Ben Zakit. A close look reveals the trademark "ZAK SPC" on the cowl. (Courtesy of the Koch collection.)

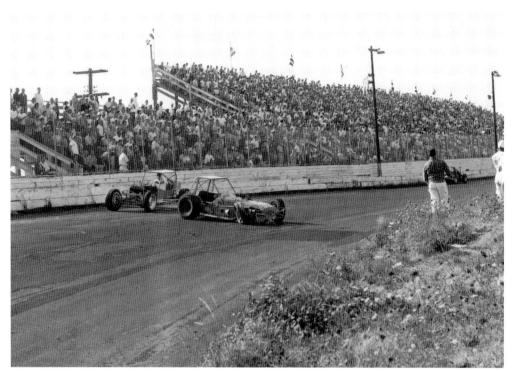

This is an image of the Zakit Special car after crashing while leading a 200-lap supermodified race in 1962. Ernie Koch was the driver. (Courtesy of the Koch collection.)

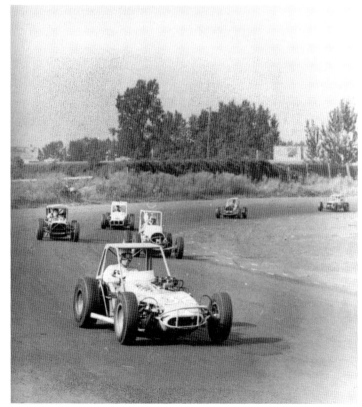

In order are Ernie Koch, Billy Foster, Art Pollard, and Bob Gregg at a 200-lap supermodified race at Portland Speedway in 1962. (Courtesy of the Koch collection.)

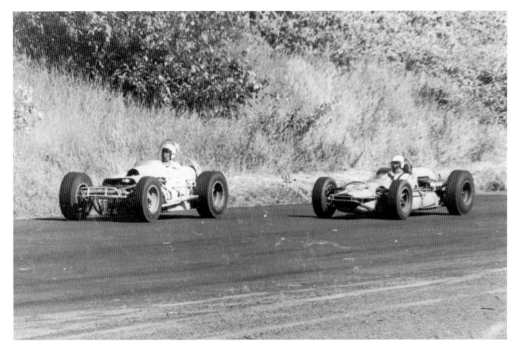

Bob Gregg leads Ernie Koch in 1965 at Portland Speedway. Koch is in one of the first rear-engine cars developed to run in the Indianapolis championship series. (Courtesy of the Koch collection.)

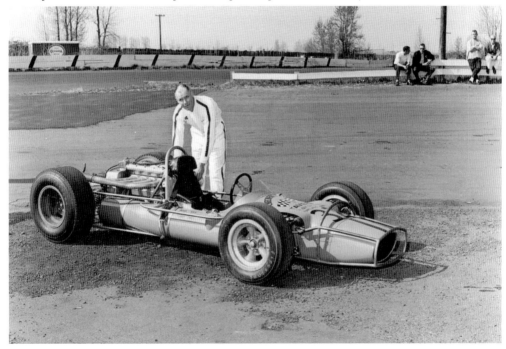

Here is Ernie Koch with Ben Zakit's rear-engine car in the early 1960s. Koch drove in the 1960–1962 Champ Car seasons and was a leading driver at Portland Speedway for many years. (Courtesy of the Koch collection.)

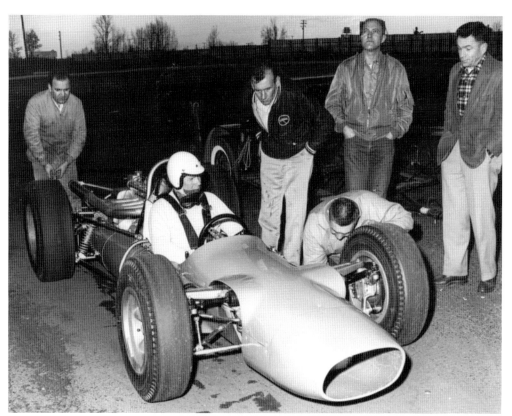

Ernie Koch is seen testing another rear-engine car at Portland Speedway in the mid-1960s. Ray Jackson is shown at the back of the car, and Keith Randol is wearing the Bardahl coat. (Courtesy of the Koch collection.)

This 1964 event program for Portland Speedway and Jantzen Beach Arena includes photographs of the 1963 class champions: Don Nelson (upper left) for supermodifieds, Kuzie Kuzmanich (upper right) for late-model stock cars, Fred Connett (lower left) for claimers, Ray Wearne lower center) for sprint cars, and Ray Williams (lower right) for jalopies. (Courtesy of the Speedway Old-Timers.)

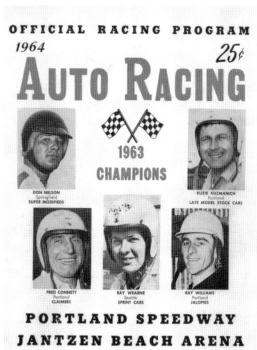

OFFICIAL RACING PROGRAM
1964 25¢
AUTO RACING
1963
CHAMPIONS

DON NELSON
Springfield
SUPER MODIFIEDS

KUZIE KUZMANICH
Portland
LATE MODEL STOCK CARS

FRED CONNETT
Portland
CLAIMERS

RAY WEARNE
Seattle
SPRINT CARS

RAY WILLIAMS
Portland
JALOPIES

PORTLAND SPEEDWAY
JANTZEN BEACH ARENA

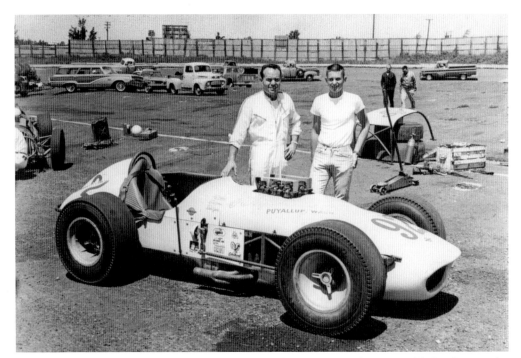

Art Pollard (left) poses with a sprint car in the mid-1960s. Note the removable hardtop in the background. Putting that top on the car made it a supermodified. (Courtesy of OMMA.)

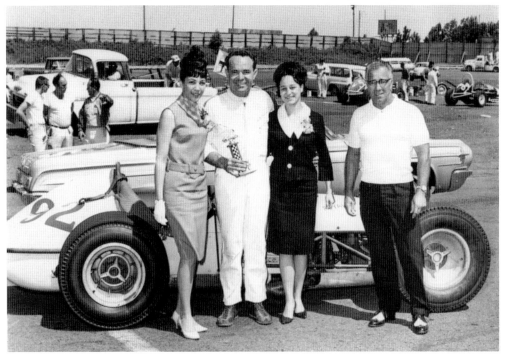

Art Pollard (left) and Pat Vidan (right) pose with unidentified trophy girls sometime between 1963 and 1964. (Courtesy of OMMA.)

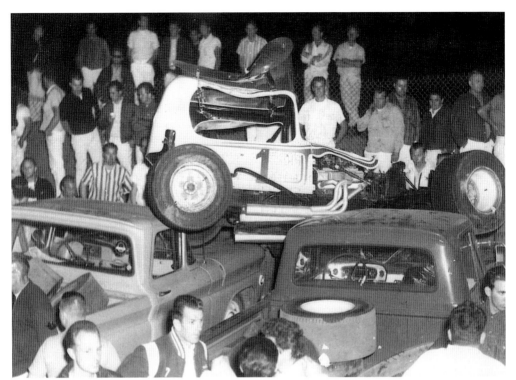

Someone did an exceptionally bad job of parking this supermodified, landing it on top of two push trucks. (Courtesy of OMMA.)

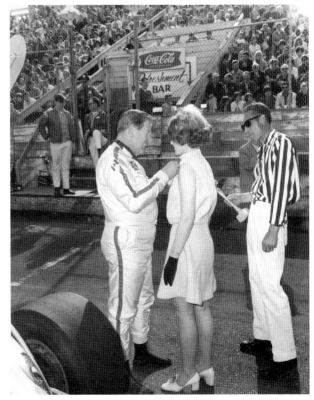

Supermodified driver Rebel Jackson (left) poses with an unidentified trophy girl and starter Ed Rose. Jackson was killed while racing supermodifieds at Portland Speedway in 1994. (Courtesy of OMMA.)

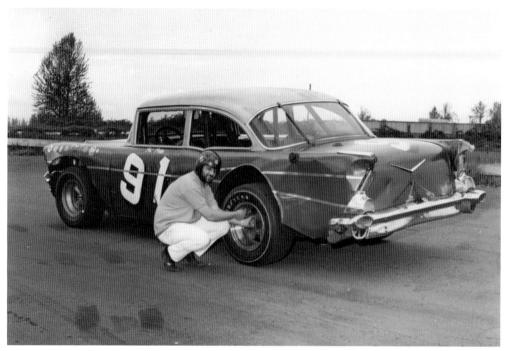

Pat Pattee, a radio personality on KISN in Portland, did a lot to generate interest in racing at Portland Speedway in this era. (Courtesy of the Koch collection.)

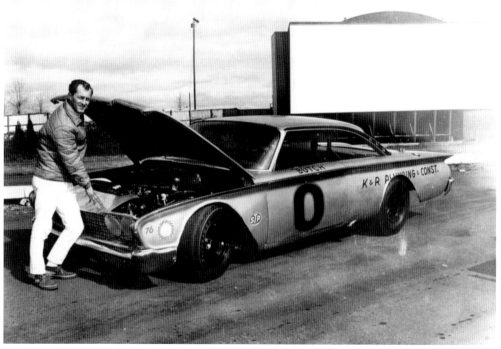

A man now known only as "Butch" drove this 1960 Ford Starliner two-door hardtop stock car. (Courtesy of OMMA.)

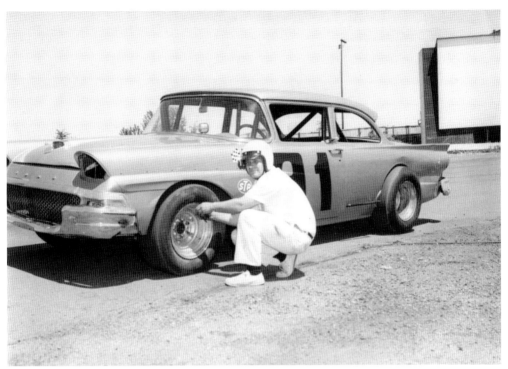

An unidentified driver poses with a Ford stock car in the early 1960s. (Courtesy of OMMA.)

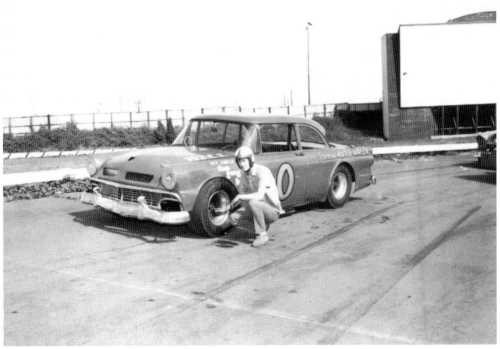

This is another unidentified stock car driver in the early 1960s. (Courtesy of the Speedway Old-Timers.)

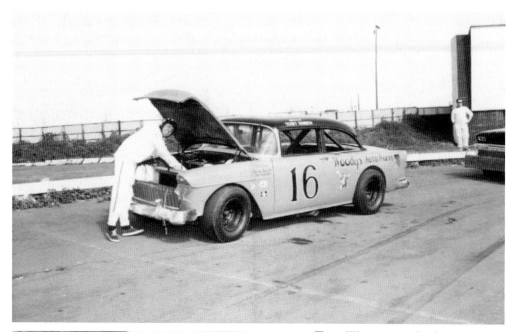

Terry Warren was the driver of this stock car in the early 1960s. (Courtesy of the Speedway Old-Timers.)

Stock car racers pose with the trophy girl in the mid-1960s. (Courtesy of the Speedway Old-Timers.)

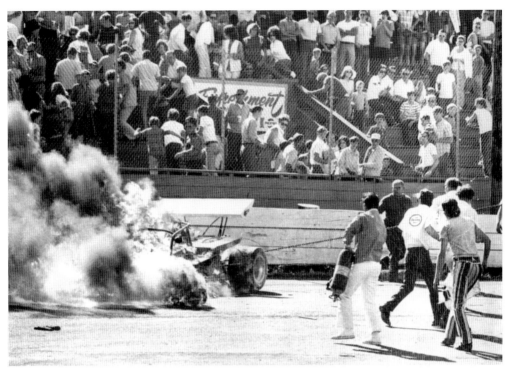

Workers respond to a car fire in the 1970s, the heat of which caused spectators in the stands to head for safety. (Courtesy of OMMA.)

Occasionally, sports car racing and time trials would be held at Portland Speedway. Cars would drive counterclockwise around the half-mile outer oval, then make a sharp left turn onto the quarter-mile inner oval, and drive clockwise to another sharp left back onto the outer oval, creating a short road course. (Courtesy of OMMA.)

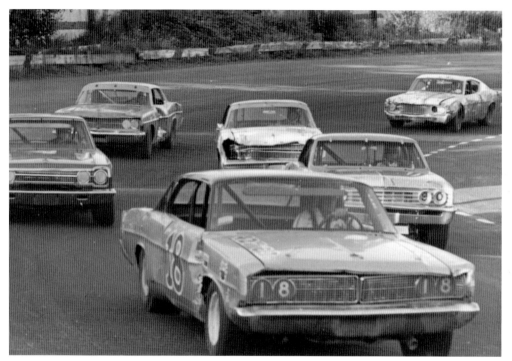

As the 1960s and 1970s progressed, stock car racing kept pace with recent models, but the nature of local stock car racing stayed the same. NASCAR professionals returned to Portland Speedway in 1964 with the NASCAR Pacific Coast Late-Model Series, revisiting the track many times until 1969. (Courtesy of OMMA.)

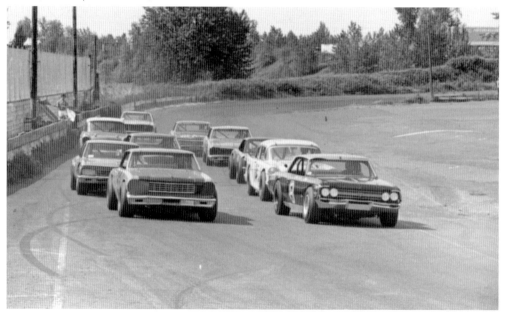

In 1971, the Winston West Series took over, racing at Portland almost every year until 2000. (Courtesy of the Speedway Old-Timers.)

RACING ON: 1960–1980

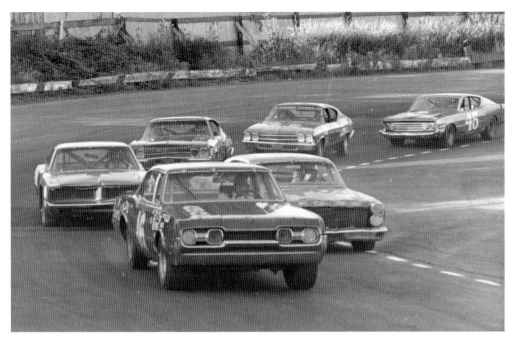

Some of these old stock cars would be worth quite a bit of money today, if they could be found intact. (Courtesy of the Speedway Old-Timers.)

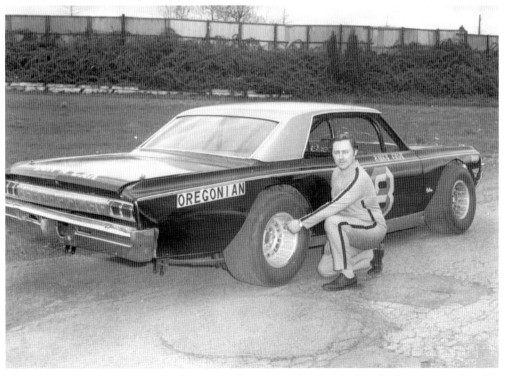

This driver worked at the *Oregonian* newspaper and raced under the handle "Dirty Ervy" in this 1964 Oldsmobile Cutlass. (Courtesy of OMMA.)

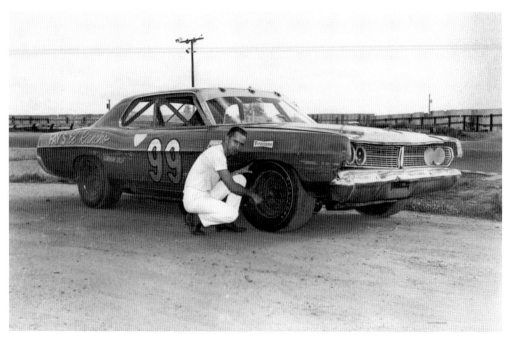

This unidentified stock car driver hailed from Gorman, California. Many racers from up and down the West Coast came to Portland for its top-quality racing. (Courtesy of OMMA.)

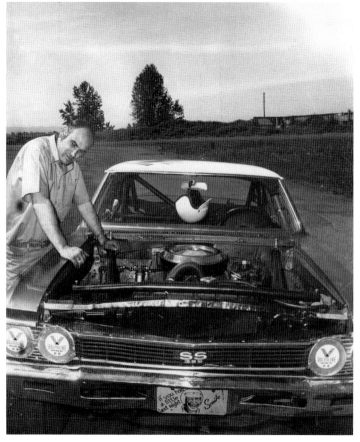

John Langan considers the engine in his stock car. Note the front license plate art; clearly, Langan had a sense of humor. (Courtesy of OMMA.)

John Langan took a great deal of pride in the presentation of his 1966 Chevy Chevelle SS 396. (Courtesy of OMMA.)

Here is John Wallingford with his 1966 Chevelle stock car. (Courtesy of OMMA.)

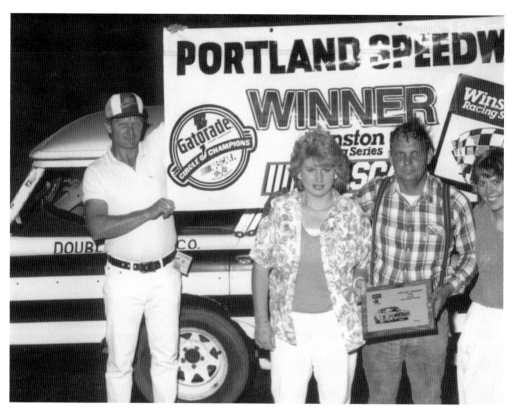

Among the leading stock car racers of the 1970s was "Fast Freddie" Miles, shown here collecting one of his many trophies. (Courtesy of OMMA.)

This 1976 program from Portland Speedway featured a patriotic theme for the nation's bicentennial. (Courtesy of OMMA.)

4

An Institution
1 9 8 0 – 2 0 0 0

After cycling through several promoters in just a few years, Portland Speedway faced a challenging situation: without a steady administration, the quality of racing was declining. Wrestling promoter and flea market manager Sandy Barr took over about 1981 and managed racing at the speedway for three years.

Old-timers recall that Barr promoted racing as if it were a wrestling match, creating and highlighting rivalries between drivers. However, the strategy did not work well, and both gate attendance and driver participation steeply declined. Investment in facility maintenance was also down, and the speedway went into disrepair.

A team composed of Bill and Bob Barkhimer and Dennis Huth, who later went to work for NASCAR, purchased the assets, obtained a new lease for Portland Speedway, and at the end of the 1983 season, replaced Barr as the track manager.

Participants recall that 12 dumpster loads of trash were removed from the facility and a new coat of paint applied to the grandstands and fences.

By this time, NASCAR was the primary focus of the speedway racing operation. Both Winston West and Northwest Tour ran at the speedway at least once a year in this era, with Winston West running its last race on the pavement on July 4, 2000, and the Northwest Tour running its final Portland Speedway event on April 29, 2000.

In 1994, a demonstration race for the new Craftsman Truck Series was awarded to the speedway, and fan response was tremendous. The trucks then ran every year until 1998.

"We announced a special exhibition of the brand-new NASCAR SuperTrucks Series. I've never seen anything like it. I had to hang out the SOLD OUT sign, and that broke my heart," says former speedway manager Craig Armstrong.

Armstrong began his career as Portland Speedway's announcer in 1987, moving up to manager and promoter in the summer of 1988.

"The 1990s were the second golden era. We lit the half mile and brought the late models, which enormously increased our fan base. 1998 was probably our greatest year in terms of what we had accomplished. We had 22 to 25 late models every time we opened. We would get 30 to 40 Limited Sportsman, up to 60 Street Stocks, and 20 to 25 of the Bumping Bombers—and a legitimate 1,500 to 2,000 paid fans in the stands every time we had a Fast Friday show. It put us in the top 5 percent of speedways nationally," Armstrong says.

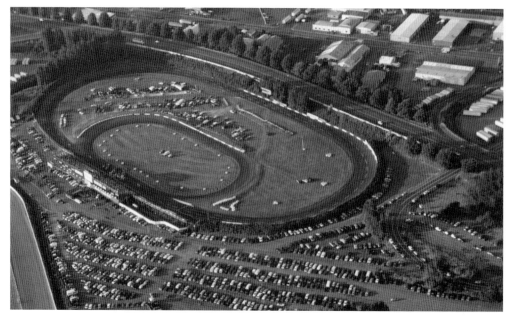

Portland Speedway is seen here from the air in the late 1980s. The drive-in theater is long gone, but a few of the humps inside the quarter-mile inner oval are still visible. The eighth-mile dirt oval for go-karts had not yet been built in the south infield, but the pit road had been laid in the north infield. (Courtesy of OMMA.)

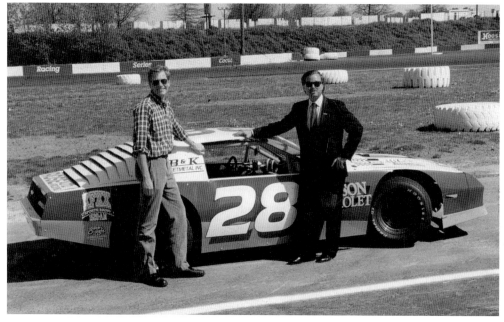

Bob Kehoe (left) and Craig Armstrong started their careers as Portland Speedway's announcers in the 1980s. Armstrong went on to become the facility manager and promoter, and Kehoe went on to write for the *Oregonian*. For a time, the two hosted a racing-oriented radio show. (Courtesy of OMMA.)

AN INSTITUTION 1980–2000

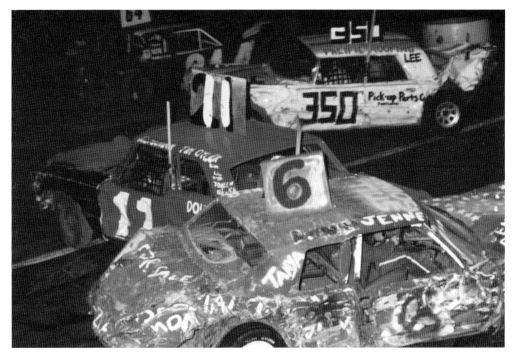

Demolition Derby was just one of the fun attractions that ran at Portland Speedway in this era. (Courtesy of OMMA.)

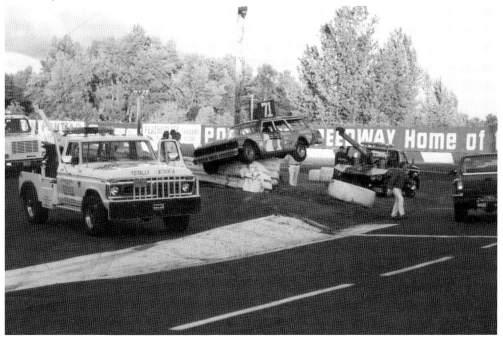

Crashes are inherent to racing, and here, a safety crew rescues a car off the guardrail of the quarter-mile inner oval. The wreckers and push trucks are an indispensable part of any speedway's track crew. (Courtesy of OMMA.)

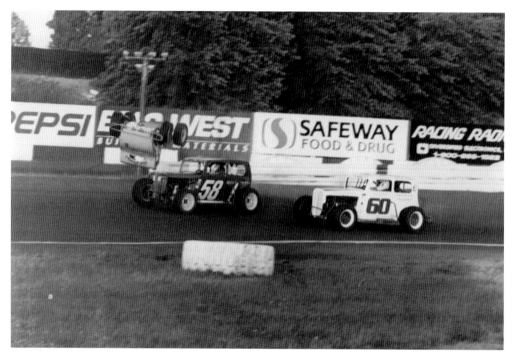

Dwarf cars running at Portland Speedway show off their spectacular style, with one competitor flying upside down. Powered by motorcycle engines, these cars put on a great show. (Courtesy of OMMA.)

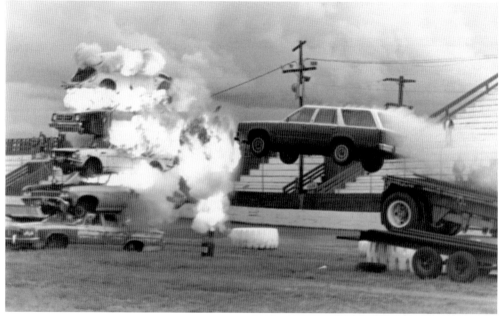

A stunt driver jumps a station wagon through a stack of burning junk cars. Now, that is entertainment! Gimmicks such as this added a level of flair to many events, especially Enduro races in the 1990s. (Courtesy of OMMA.)

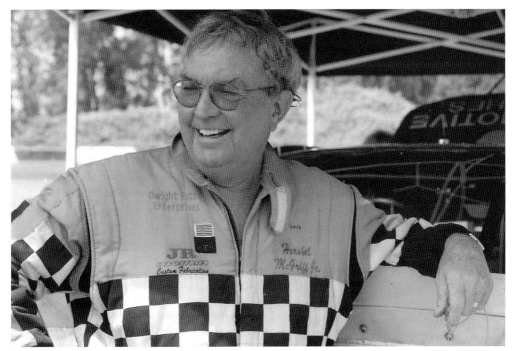

Hershel McGriff was a fixture at Portland Speedway from almost the beginning. McGriff competed in the first Portland Speedway race after World War II even though he was not yet 18. The following year, McGriff won the first race on the new pavement at the speedway. McGriff went on to race in NASCAR, La Carrera Panamericana, and the 24 Hours of Le Mans. McGriff raced in the final race on Portland Speedway's pavement in 2000, finishing 14th. (Courtesy of Jerry Boone.)

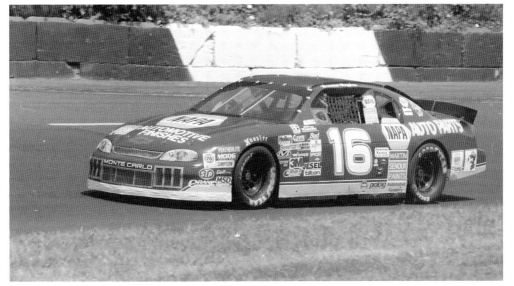

Hershel McGriff shows off the style that earned him a place on the list of the 50 greatest drivers ever to compete in NASCAR. (Courtesy of Jerry Boone.)

Hershel McGriff Jr. also raced at Portland Speedway. He is shown here collecting a trophy for a win. (Courtesy of OMMA.)

This is Kevin Stimberis at Portland Speedway with the Northwest Tour in the early 1990s. Promoter Craig Armstrong is seen at right. Stimberis went on to work with Robert Yates Racing and Roush Fenway Racing. (Courtesy of OMMA.)

AN INSTITUTION 1980–2000

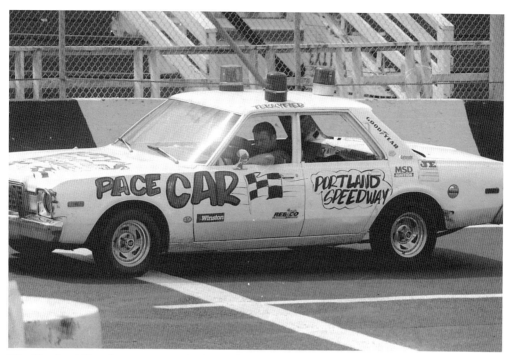

The Portland Speedway pace car, both nicely painted and well turned out, was a familiar sight for racers throughout this era. (Courtesy of Jerry Boone.)

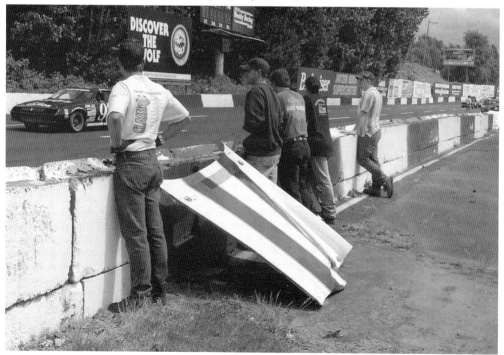

After the pit road was paved in the late 1980s, pit crews had a short stretch of wall along the back straight where they could signal to drivers as they went by. (Courtesy of Jerry Boone.)

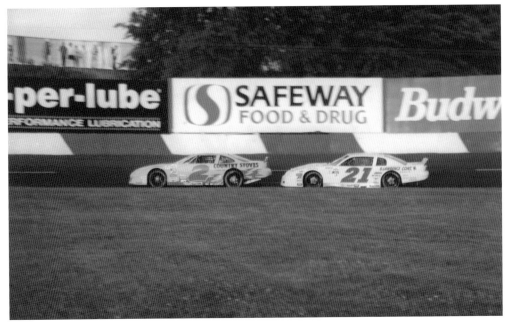

Among the many notable NASCAR drivers who drove at Portland Speedway were Joe Bennedetti (No. 2) and Bill Lawrence (No. 21), shown here in the late 1990s. (Courtesy of OMMA.)

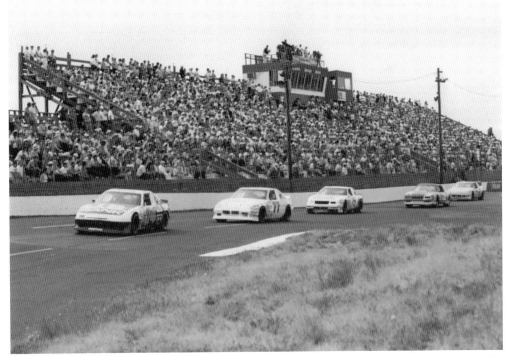

Hershel McGriff leads a Winston West race in the mid-1980s. In this era, drivers such as Dale Earnhardt, Ernie Irvan, Bill Elliott, Derrike Cope, Jim Bown, and Bobby Allison all competed at Portland Speedway. (Courtesy of OMMA.)

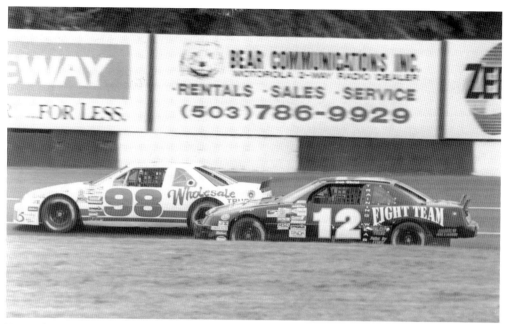

Dan Obrist in the No. 12 car chases Jim Bown in the No. 98 car during the 1995 Reser's Fine Foods 200 Winston West race. (Courtesy of OMMA.)

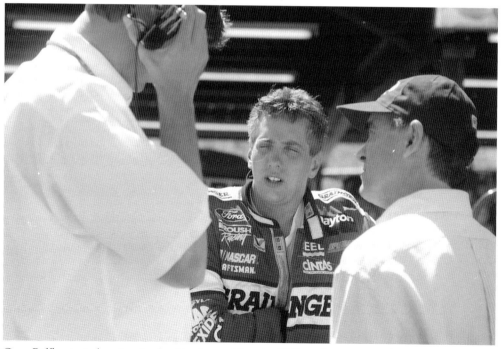

Greg Biffle started racing in the Northwest Tour in 1989 and went on to have a stellar career, including the 2000 NASCAR Camping World Truck Series championship, the 2002 NASCAR Nationwide Series championship, and second in the 2005 NASCAR Sprint Cup Series. (Courtesy of Jerry Boone.)

Shown here around 1999, Pat Bliss is the brother of Mike Bliss and a great late-model driver in his own right. (Courtesy of Jerry Boone.)

Tony Schmidt was another late-model competitor in the late 1990s. Schmidt won the Rookie of the Year award in 1995 and finished third in the season standings for both 1999 and 2000. (Courtesy of Jerry Boone.)

AN INSTITUTION 1980–2000

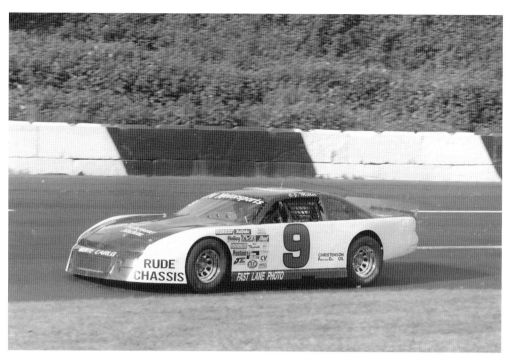

C.J. Miller was another late-model competitor who enjoyed some success in the final years of Portland Speedway. (Courtesy of Jerry Boone.)

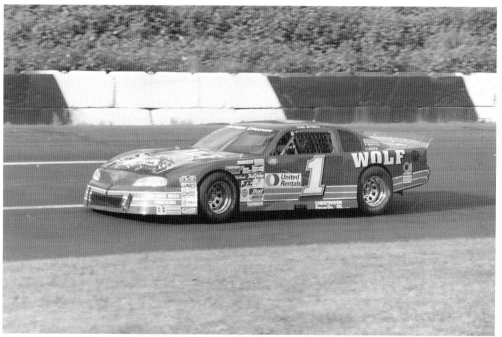

Doug Mitchell won the 1996 Limited Sportsman championship at Portland Speedway as well as the 2000 Portland Speedway Late-Model Irontech Rookie of the Year award. (Courtesy of Jerry Boone.)

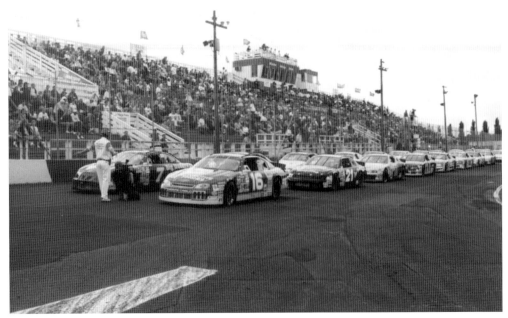

Sean Woodside has the pole position, with Gary Smith on the outside, for the 1999 Grainger Industrial Supply 200 Winston West race, held on August 14, 1999. (Courtesy of OMMA.)

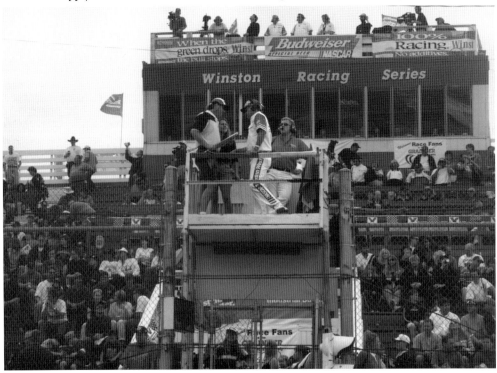

In later years, a raised starter stand was built to comply with racing regulations. Previously, the starters stood down on the racing surface with the cars. The announcer's booth was also constructed above the grandstands. (Courtesy of OMMA.)

AN INSTITUTION 1980–2000

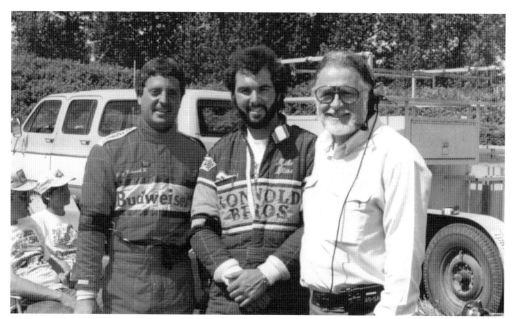

Bill Vukovich III (left) and Mike Bliss take a moment at the speedway in the 1980s. Vukovich was the 1988 Rookie of the Year at the Indianapolis 500 but was tragically killed in a sprint car accident in 1990. (Courtesy of OMMA.)

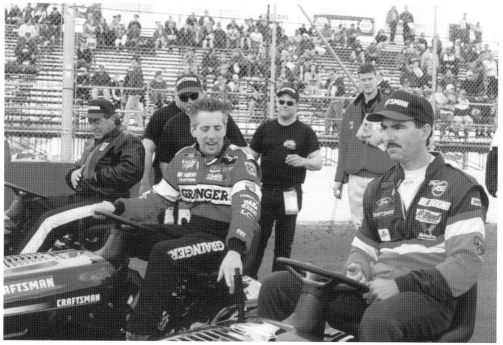

From left to right, Chuck Bown, Greg Biffle, and Mike Bliss prepare to race Craftsman riding lawn mowers at the NASCAR Craftsman Truck Series race on April 25, 1998. (Courtesy of OMMA.)

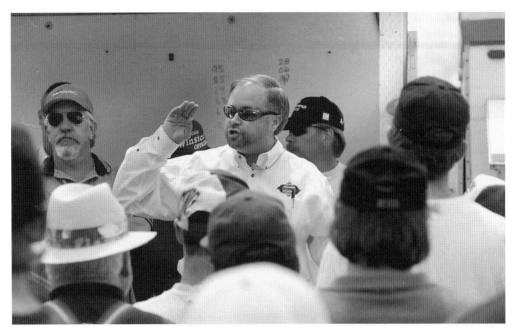

Here is Portland Speedway manager and promoter Craig Armstrong (center) and Enduro series official Jim Mikelson (left) holding a driver meeting in advance of a 300-lap Enduro race. Armstrong always asked the drivers to recite the main rule of Portland Speedway: have fun! (Courtesy of Jerry Boone.)

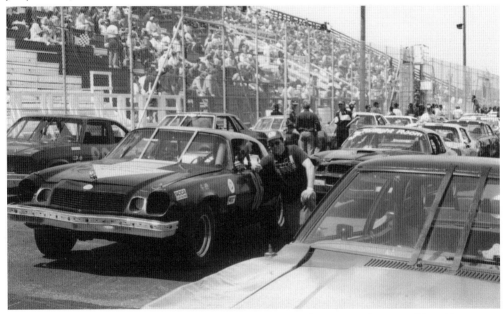

Enduro racing was popular among regular competitors and occasional racers alike. The events were held on Memorial Day and Labor Day and went on rain or shine, but were always fun. Crewman Vince Van De Coevering is shown with the No. 86 Fizzball Racing Chevy Camaro of Jeff Zurschmeide. (Author's collection.)

AN INSTITUTION 1980–2000

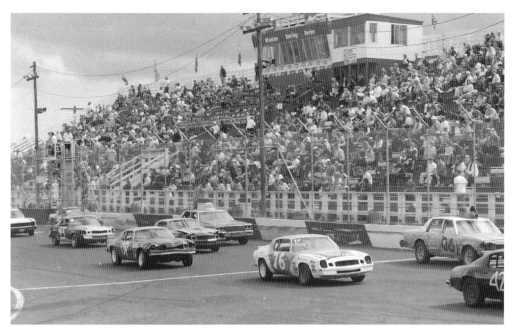

One of the signature features of an Enduro race was the occasional caution flag that the officials would throw to turn the entire field around to race in the right-turning direction for up to 100 laps. This evened out tire wear and added another driving challenge as well. (Courtesy of Jerry Boone.)

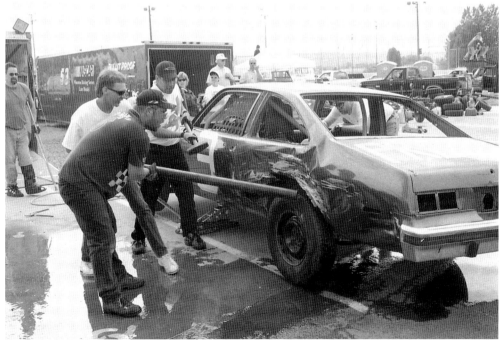

Impromptu bodywork was always part of Enduro racing. This crewman is "rolling the bat" to pull bent sheet metal away from the tires of this race car. (Courtesy of Jerry Boone.)

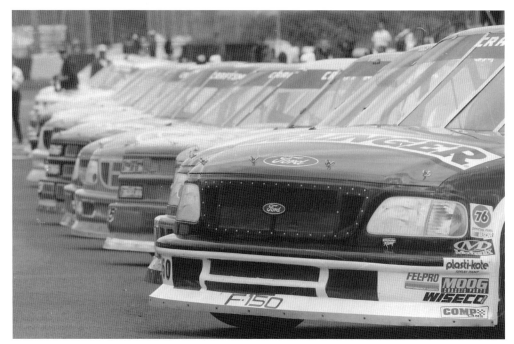

NASCAR's popular SuperTruck Series did a demonstration race at Portland Speedway in 1994 and was an instant hit. The event sold out at the gate and returned four more times—once in 1995 as the SuperTruck Series and three more times from 1996 to 1998 as the Craftsman Truck Series. (Courtesy of Jerry Boone.)

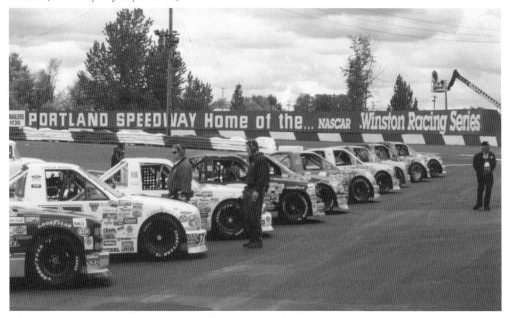

The NASCAR trucks offered another chance for local drivers to compete with nationally known drivers. Local heroes such as Dan Obrist, Greg Biffle, Mike Bliss, Jim and Chuck Bown, and others all competed in trucks. (Courtesy of OMMA.)

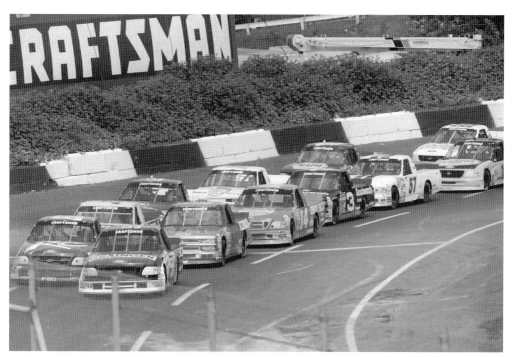

On a short track like Portland, truck racing was close and action packed. The events always drew a full crowd in the stands and national television coverage. (Courtesy of Jerry Boone.)

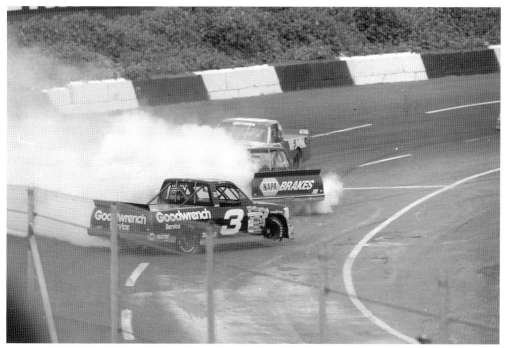

With Portland's tight turns and comparatively rough pavement, a simple spin could turn into a major multicar incident in the blink of an eye. (Courtesy of Jerry Boone.)

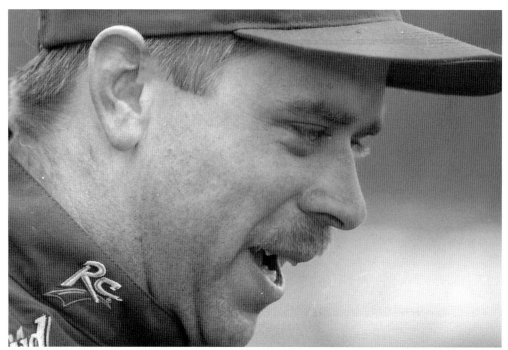

Stacy Compton of Virginia won the final Craftsman Truck Series at Portland in April 1998. Compton started outside on the front row and led 198 of the race's 200 laps. (Courtesy of Jerry Boone.)

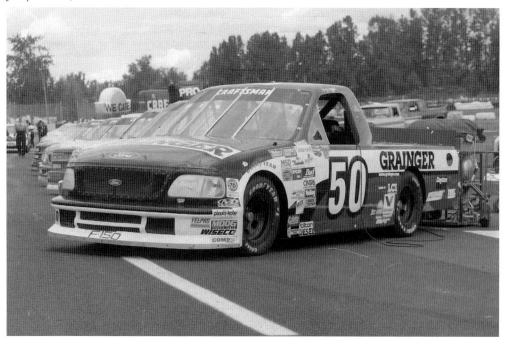

Greg Biffle, of Camas, Washington, secured sponsorship from Grainger and won the Rookie of the Year award in the 1998 Craftsman Truck Series. (Courtesy of Jerry Boone.)

Greg Biffle got his start racing at Portland Speedway. Promoter Craig Armstrong recalls, "In January of 1989, Greg came out to test in a Northwest Tour car for the first time. I had a stopwatch and it was a gorgeous day, and by about lap 11 or 12, he'd broken the track record. He's a natural." (Courtesy of Jerry Boone.)

Ron Hornaday (back row, second from right), of Palmdale, California, won the 1996 Craftsman Truck Series at Portland Speedway on his way to winning the series championship that year. He was also the 1998 Craftsman Truck Series champion. (Courtesy of OMMA.)

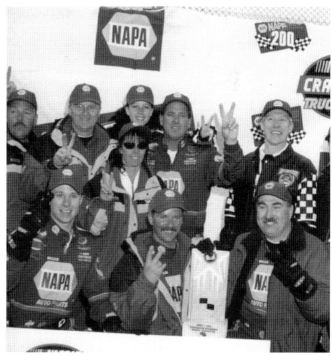

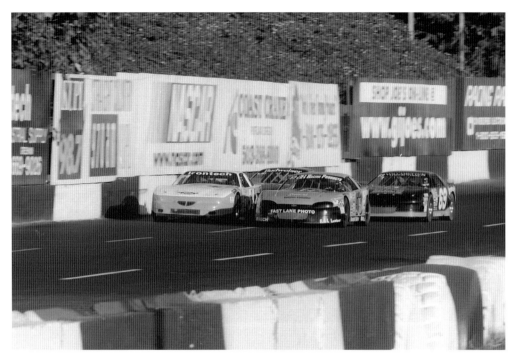

Late-model stock cars were the mainstay of Fast Friday racing throughout the 1990s. This class trained drivers to move up to the NASCAR Northwest Tour and Winston West Series. (Courtesy of Jerry Boone.)

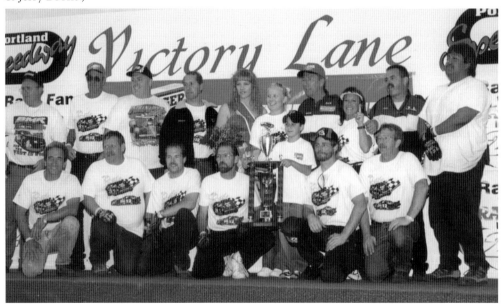

Late-model competitor Dan Obrist (back row, center right wearing racing suit and ball cap) was a frequent visitor to the winner's podium in the 1990s. Obrist often raced in Winston West and once in the Craftsman Truck Series. Obrist had two starts in Winston Cup: at Sonoma in 1995 and Suzuka in 1996. (Courtesy of OMMA.)

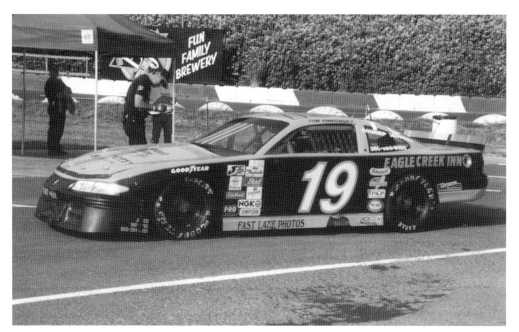

Tom Pinkowsky won three late-model championships at Portland Speedway, then switched to Grand American Modified when the track was returned to clay in 1999, picking up a championship in that class in 2001. (Courtesy of OMMA.)

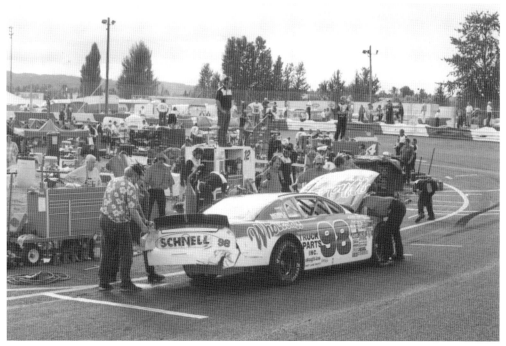

The No. 98 Chevrolet of Kevin Culver was a consistent top-five car in Winston West races at Portland Speedway in the 1990s. Culver's best finish was third place on June 1, 1996. (Courtesy of OMMA.)

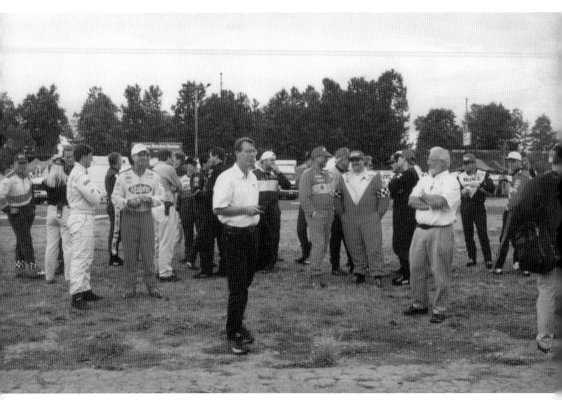

Here is a typical Winston West Series drivers' meeting at Portland Speedway in the 1990s. Butch Gilliland is seen in the Ralph's driver's suit at center left. (Courtesy of OMMA.)

Late in the history of Portland Speedway, an eighth-mile dirt track for go-kart racing was added in the south infield, which had been unused since the days of the drive-in theater. (Courtesy of Jerry Boone.)

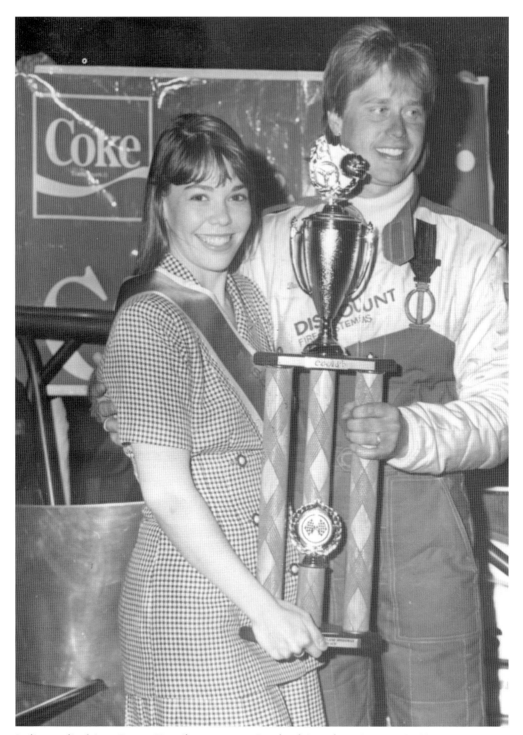

Indianapolis driver Davey Hamilton came to Portland Speedway in June 2000 to compete in a Supermodified Racing League (SRL) race. Hamilton finished in fourth place. (Courtesy of OMMA.)

5

END OF AN ERA

2 0 0 0 – 2 0 0 2

By the end of the 1990s, trouble was looming for Portland Speedway. Manager Craig Armstrong faced an intractable problem. "The asphalt needed some work. The front stretch, turns, and the quarter-mile track needed it badly," Armstrong says.

Yet the lease that gave him the right to run the racing facility had a clause that allowed the landowners to end his tenancy at the end of each year. This meant that Armstrong could not secure long-term financing for improvements.

"After the 1998 truck race, NASCAR went to a live pit stop format for the trucks. When they told us we had to create a hot pit area, it would cost $200,000 to $250,000 to build that," says Armstrong.

Without the big events, the regular weekly racing was not enough to keep the speedway going as a business. Then an opportunity presented itself in the form of World of Outlaws.

"About the latter part of the summer of 1999, World of Outlaws approached my partner and said that if we would convert the track to dirt, they would love to come to the Portland market," says Armstrong.

The change meant displacing many of the regular competitors, but finances left Armstrong no other option. The demolition of the asphalt racing surface was announced in 1999, and attendance soared as drivers enjoyed their last chances on the historic pavement first laid back in 1946.

The demolition of the asphalt took place in July 2000, and truckloads of clay were brought in and spread over the track circuit. The inner quarter-mile circuit was extended to one-third of a mile, but the outer track stayed at half a mile. Racing resumed in August 2000 with cars developed for racing on a clay surface. Many pavement drivers did not make the switch, however, and attendance diminished.

As the change played out, World of Outlaws came to Portland just twice—in 2000 and 2001—and then removed Portland from its schedule. The loss was devastating.

"Closing it was the hardest thing. I felt personally responsible for that. I felt I had let down the drivers, crews, fans, sponsors, and everyone. Had I to do it again with the knowledge of what happened, I never would have converted to dirt," Armstrong says.

The end of the 2001 season marked the close of competition at Portland Speedway. The buildings and bleachers were demolished in 2003, and the land lies barren today.

Speedway manager and promoter Craig Armstrong begins removing the asphalt from Portland Speedway in July 2000. (Courtesy of OMMA.)

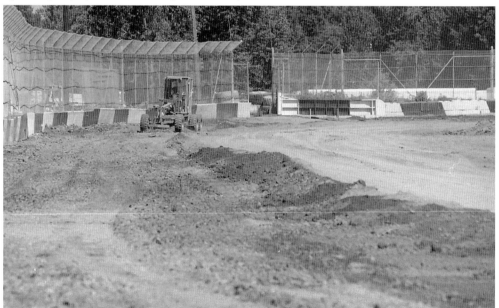

The conversion started on July 5, 2000, the day after the final Winston West Series race, and was completed by August 3. (Courtesy of Jerry Boone)

The clay was painstakingly spread and packed down to provide the smoothest-possible racing surface. The transition to clay actually added a little bit of length to the inner quarter-mile oval, extending it to almost one-third of a mile. (Courtesy of Jerry Boone.)

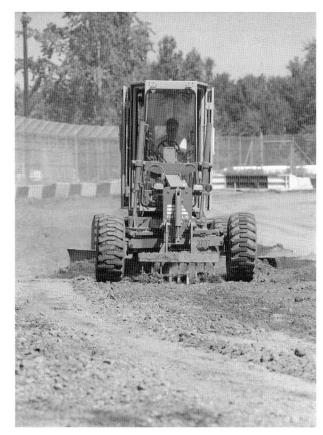

Clay-racing expert Bill Arnold from nearby Willamette Speedway in Lebanon, Oregon, examines the clay as it is being spread. (Courtesy of Jerry Boone.)

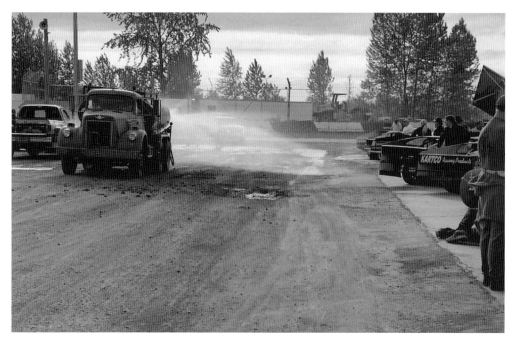

When the clay was dry, it provided reasonable traction, but to avoid tearing up the surface, a water truck was used to wet the clay. When it was wet, the clay offered a slick surface that was positively icy and treacherous to race on. (Courtesy of Jerry Boone.)

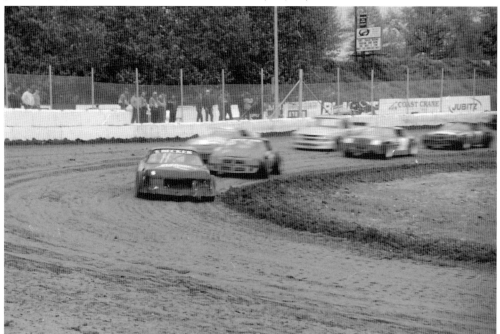

With the beginning of the summer season of 2000, Street Stock racing resumed with only minimal changes to the cars. Enduro stock racing also continued with no changes at all to the cars. (Courtesy of Jerry Boone.)

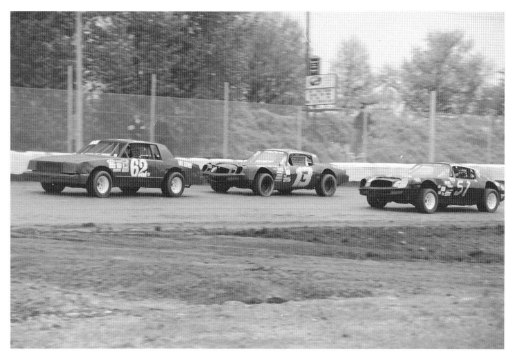

Street Stock racers are competing on the half-mile circuit in 2000. (Courtesy of Jerry Boone.)

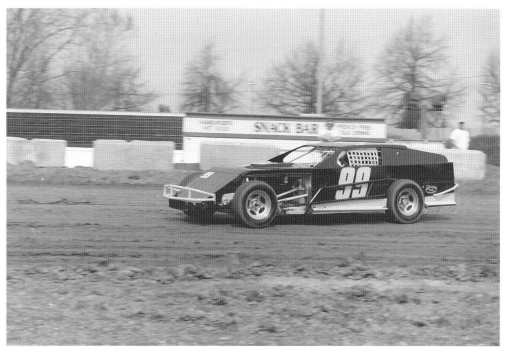

Grand American Modified cars also came to compete at Portland Speedway. With two other clay ovals operating nearby in Banks and St. Helens, Oregon, there was a ready supply of cars to compete. (Courtesy of Jerry Boone.)

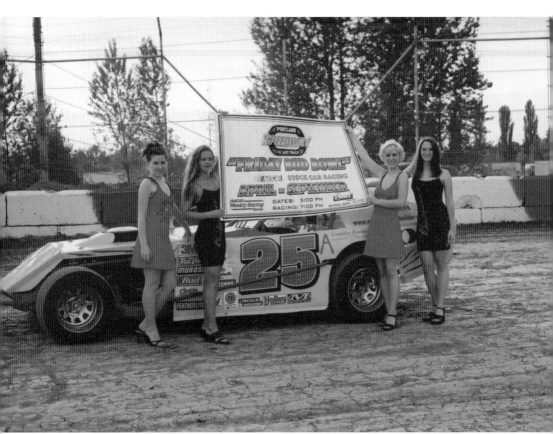

Weekly racing resumed on the clay on Friday nights before the end of September 2000. The new lineup included Short Track Sportsman, Grand American Modified, Bombers, Women's Racing, Figure 8, and Street Stock. (Courtesy of OMMA.)

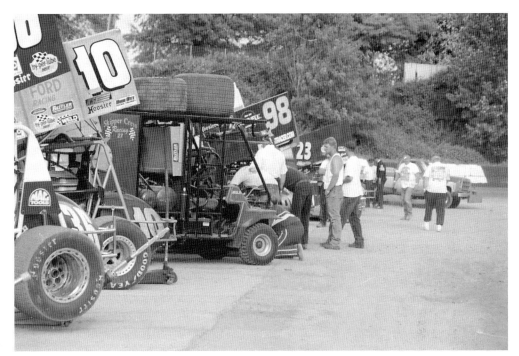

World of Outlaws came to Portland Speedway for a doubleheader on August 25–26, 2000. There was a 25-lap preliminary race on Friday night, then a 30-lap A-Main feature race on Saturday night. (Courtesy of Jerry Boone.)

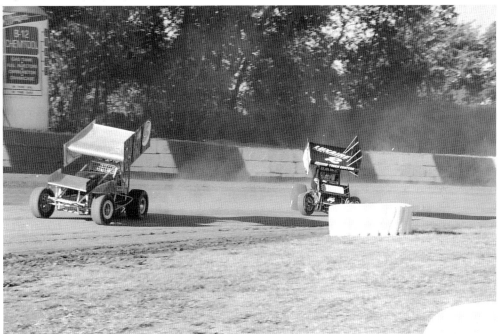

World of Outlaws brought a great fan turnout and wild racing action, including a blistering 16.431-second track record by Mark Kinser (left). (Courtesy of Jerry Boone.)

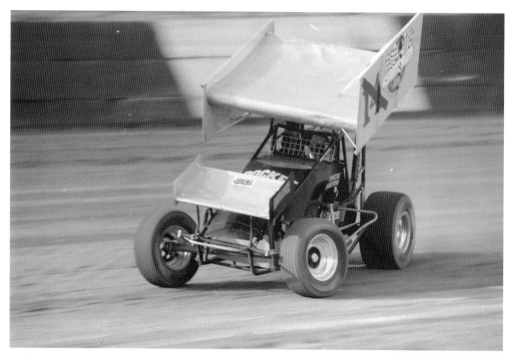

Rick Smith is shown practicing for the 2000 World of Outlaws event at Portland Speedway. (Courtesy of Jerry Boone.)

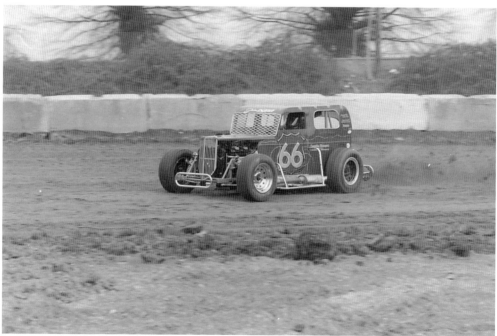

In addition to the regular lineup of stock cars and modifieds, converting to clay also brought the return of motorcycle-powered dwarf cars, designed to resemble the hardtops that once raced at Portland Speedway. (Courtesy of Jerry Boone.)

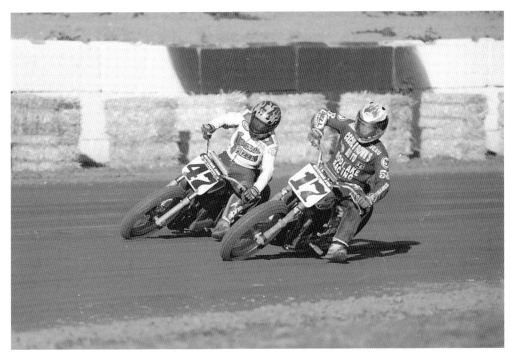

Flat-track motorcycle racers also took advantage of the new clay racing surface at Portland Speedway. (Courtesy of Jerry Boone.)

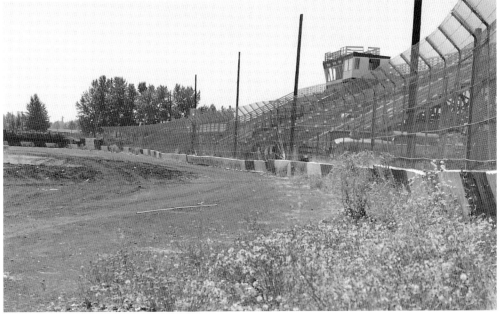

World of Outlaws did not return after its 2001 engagement, a decision that proved fatal to Portland Speedway. The track closed after the last Dirt Stock Car Open on September 22, 2001, and did not reopen for racing in 2002. The track ceased operations in March of that year. (Courtesy of Jerry Boone.)

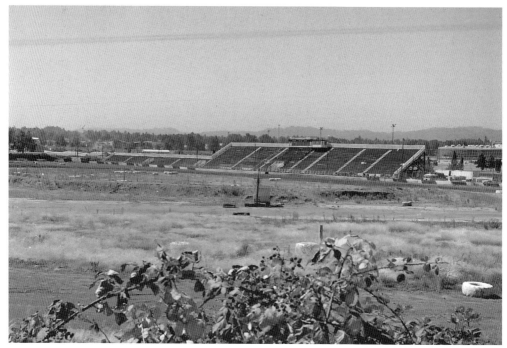

In the summer of 2003, former Portland Speedway competitor and demolition contractor Dan Obrist was given the go-ahead to level the speedway. (Courtesy of Jerry Boone.)

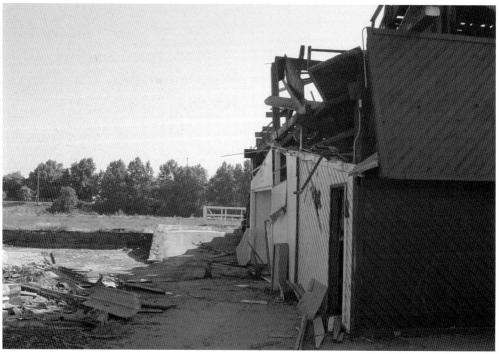

In regard to demolishing Portland Speedway's long-standing grandstands, Obrist was quoted as saying, "As soon as I pull the first board, I'll drop the first tear." (Courtesy of OMMA.)

END OF AN ERA: 2000–2002

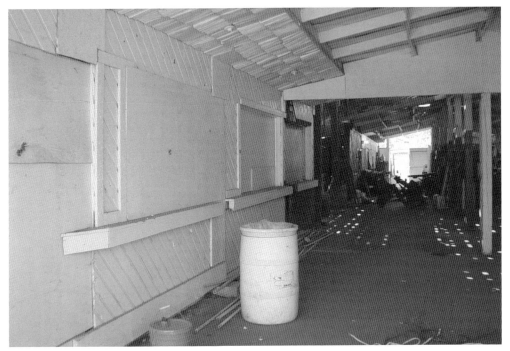

The concession stand and hall under the grandstands was silent after 65 years of use. The structure had been restored and added on to many times over the years. (Courtesy of OMMA.)

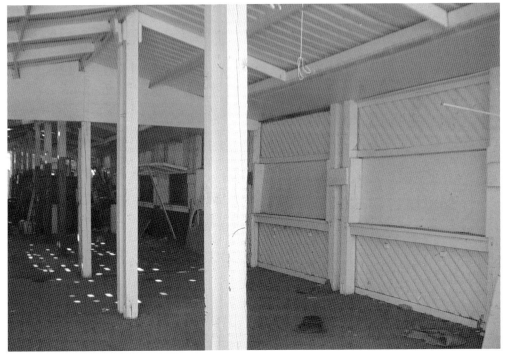

The grandstand structure was the main permanent building at Portland Speedway. It was well built and fundamentally the same as it was in 1940. (Courtesy of OMMA.)

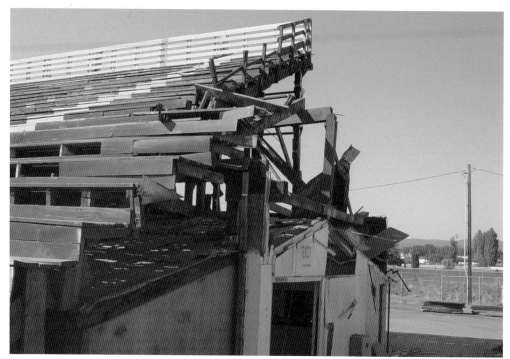

Generations of racing fans sat in these grandstands and watched many of the greatest drivers in NASCAR compete at Portland Speedway. Many who first came to the speedway as children grew up to compete or work at the facility. (Courtesy of OMMA.)

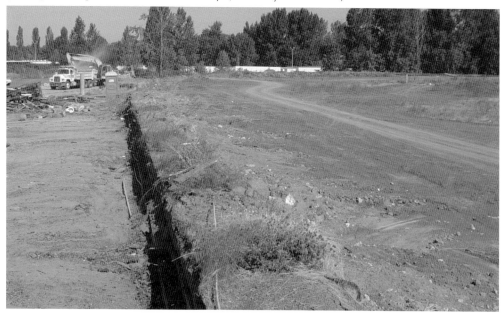

The demolition of Portland Speedway was complete; the concrete walls were removed, along with every stick of the structures. The lights were moved west to illuminate the drag strip at nearby Portland International Raceway. (Courtesy of OMMA.)

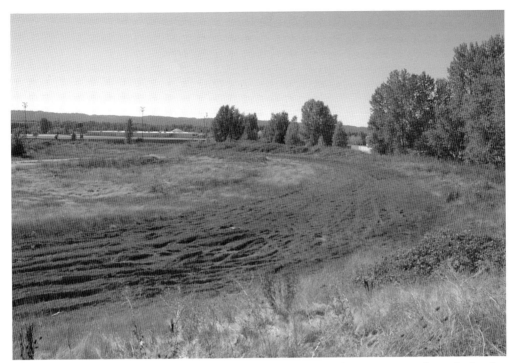

Portland Speedway is pictured here as it appeared in 2006. Little was growing through the clay racing surface, but apart from that telltale oval, it was hard to see that one of the nation's best short tracks had ever existed here. (Photograph by Jeff Zurschmeide.)

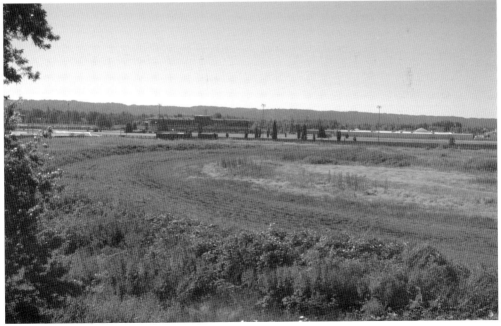

Looking westward from North Martin Luther King Boulevard, the old No. 2 turn and nearby Portland Meadows are still visible. (Photograph by Jeff Zurschmeide.)

Discover Thousands of Local History Books Featuring Millions of Vintage Images

Arcadia Publishing, the leading local history publisher in the United States, is committed to making history accessible and meaningful through publishing books that celebrate and preserve the heritage of America's people and places.

Find more books like this at
www.arcadiapublishing.com

Search for your hometown history, your old stomping grounds, and even your favorite sports team.

Consistent with our mission to preserve history on a local level, this book was printed in South Carolina on American-made paper and manufactured entirely in the United States. Products carrying the accredited Forest Stewardship Council (FSC) label are printed on 100 percent FSC-certified paper.

MADE IN THE
USA